Bookstore Cats

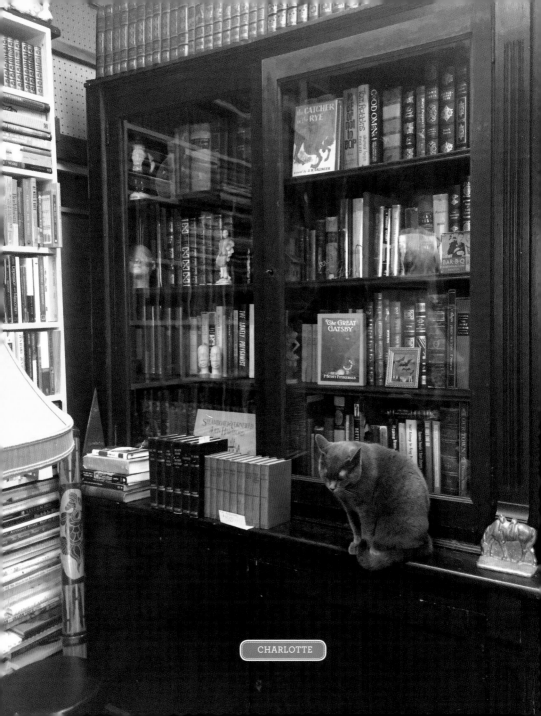

CHARLOTTE

Bookstore Cats

Brandon Schultz

Glitterati
INCORPORATED

First published in 2017 by

New York Office:
630 Ninth Ave, Ste 603
New York, NY 10036
Telephone: 212 362 9119
London Office:
1 Rona Road
London NW3 2HY
Tel/Fax +44 (0) 267 8339

www.GlitteratiIncorporated.com
media@GlitteratiIncorporated.com for inquiries

Copyright © 2017 Brandon Schultz
All rights reserved. No part of this publication may be reproduced in any form
or by any electronic or mechanical means, including information storage and
retrieval systems, without permission in writing from the publisher, except by
a reviewer who may quote brief passages in a review.

First edition, 2017
Library of Congress Cataloging-in-Publication data is available from the publisher.

Design: Liz Trovato

Hardcover edition
ISBN: 978-1-943876-52-5
Printed and bound in China
10 9 8 7 6 5 4 3 2 1

Photography credits:
Todd Holbrook: Front cover, back case, p. 160
Sophia Lee: pp. 93, 94, 97
Sarah Sovereign: p. 34
Claudia Wyler: pp. 29, 31, 33

DEDICATION

To Uncle Tom, who, like many a bookstore cat, is a keen observer,
a trusted confidant, and a quiet comfort always.

Table of Contents

Table of Contents

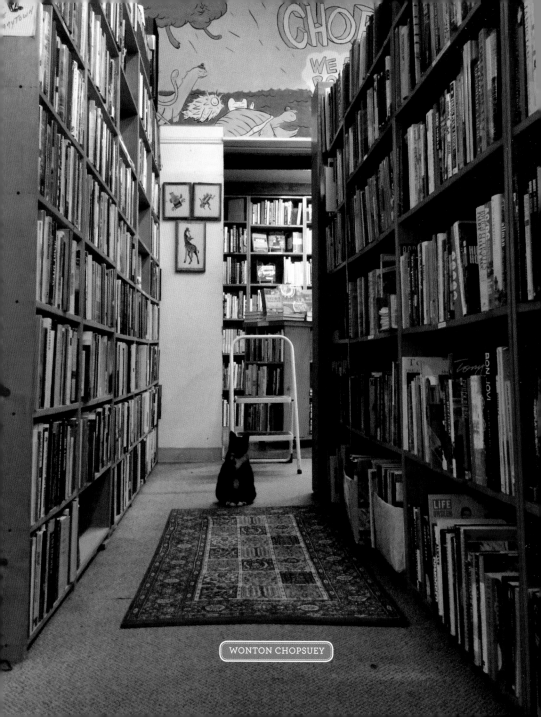

WONTON CHOPSUEY

INTRODUCTION

Confession: I'm a crazy cat person. My family members have, for the most part, been cat people. My aunt had two Siamese cats, my grandparents' house was a revolving door of rescued kitties, and I've lived with up to five felines at a time myself. I'm proud to say that I've tempered my compulsion to collect cats and I now live with only one very involved diva, Lucy. Her living room (I'm fairly sure this is Lucy's apartment and she's just letting me stay until the ice cream runs out) is lined with floor-to-ceiling bookshelves that extend to three of the four walls, filled with a variety almost as baffling as the presence of two canines in the apartment. But that's how Lucy likes it. Because she's a cat, and cats are cultured, stately, curious, and like to seem as though they know everything. Cats and books go paw-in-paw.

Around the world, bookstores continue to prove that cats and books belong together. Some employ cats, some seem to be owned by cats, and some even double as cat refuges and adoption centers. The bookstore is a place to enter quietly, search endlessly for inspiration, then dive into something unknown for no solid reason other than to satisfy an itch. In essence, it's where humans act like cats.

Nearly all cats love to sit in windows, nap in strange places, and make strong demands for treats and meals, and bookstore cats are no different. But don't think they're all the same: As varied as the characters in books, feline personalities are intense, and each is unique. It's part of what defines a cat, and what attracts

crazy cat people to them. The cats in this collection all live and/or work in bookstores, but their histories, hobbies, and attitudes are distinct. Each one has charmed me, their communities, and, for many, their impressive social media followings. Now it's time for them to charm you, and when you've met them all in these pages, perhaps you'll be inspired to plan a road trip and meet some of them in person. Sorry . . . in "cat." And, hey, don't forget to pick up a few books along the way!

—Brandon Schultz
New York

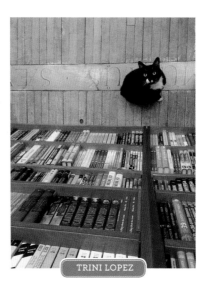

TRINI LOPEZ

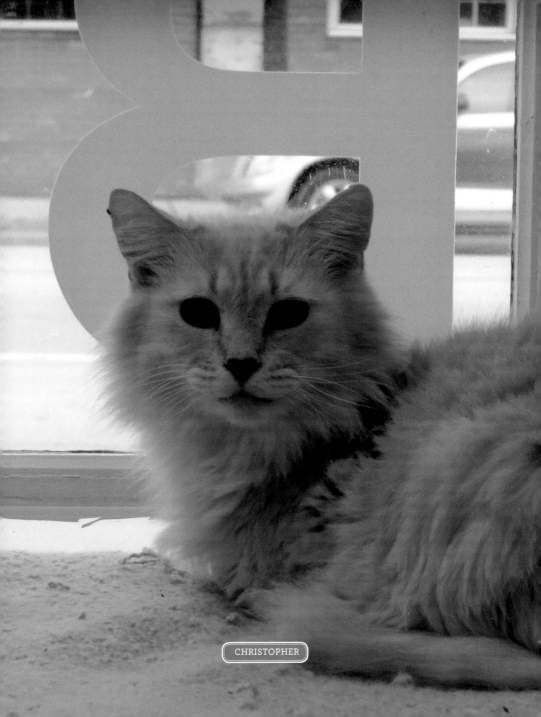

CHRISTOPHER

"But I don't want to go among mad people," Alice remarked.
"Oh, you can't help that," said the Cat: "we're all mad here.
I'm mad. You're mad."
"How do you know I'm mad?" said Alice.
"You must be," said the Cat, "or you wouldn't have come here."

⊙

"Would you tell me, please, which way I ought to go from here?"
"That depends a good deal on where you want to get to,"
said the Cat.
"I don't much care where—" said Alice.
"Then it doesn't matter which way you go," said the Cat.
"—so long as I get SOMEWHERE," Alice added as an explanation.
"Oh, you're sure to do that," said the Cat, "if you only walk
long enough."

—Lewis Carroll, *Alice's Adventures in Wonderland*

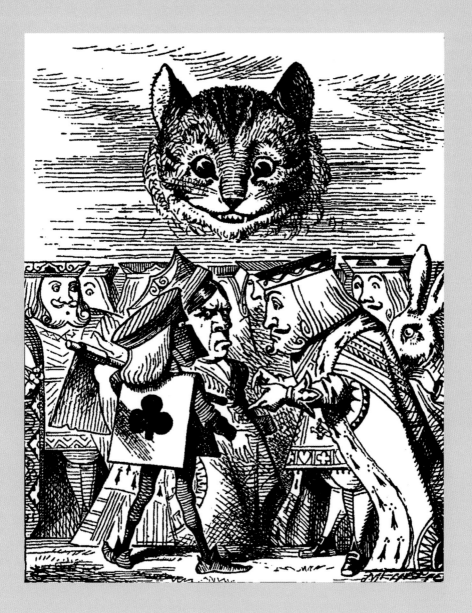

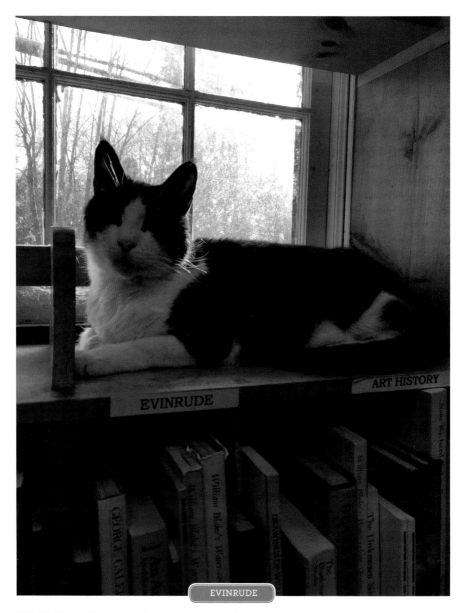

EVINRUDE

Evinrude

At least sixteen years old (he's not telling his exact age), Evinrude is the biggest and oldest cat at The Book Barn. He's also their all-star customer service representative, greeting and amusing guests since he was dropped off at the Barn as a youngster. While he may be the friendliest feline on staff, he's not exactly the brightest or most coordinated—one never knows whether he'll make it when he jumps from perch to perch. Still, The Book Barn's visitors all love Evinrude, and he graciously returns the favor.

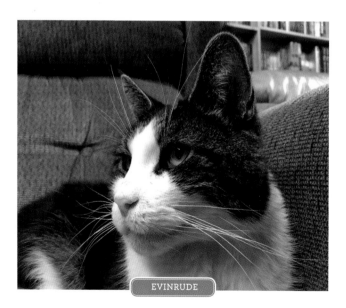

EVINRUDE

Mao

Mao is the only female member of The Book Barn's feline fleet, and she's also the alpha, having no trouble telling the males what's what. Don't be mistaken by her tiny frame; she may look like a kitten, but she's at least ten years old, and she'll be happy to tell you all about it . . . and everything else. Mao usually has urgent messages to deliver and tries repeatedly to convey them to the Barn's human staff, despite their frequent inability to understand. One message they have decoded: if the gravy isn't exactly right on the kibble, it's going back to the chef with some choice words.

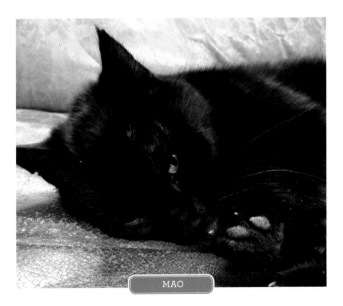

MAO

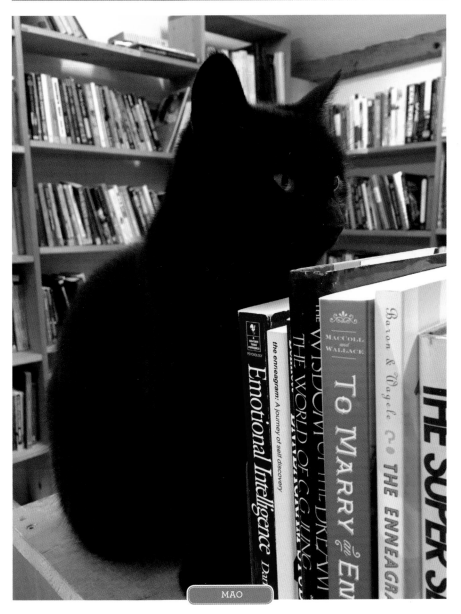

MAO

Speck

Speck is a pure-white male who was given his name because of the small black spot he sported on his forehead as a kitten. He's fond of being petted and has figured out that the desk is the most reliable place to find attention…and snacks. Speck was discovered underneath a parked car years ago as a kitten, and brought to the Barn by one of the human staff. He was petted, vetted, and made much of, and he quickly decided this accommodation was better than living under a car. Smart cat.

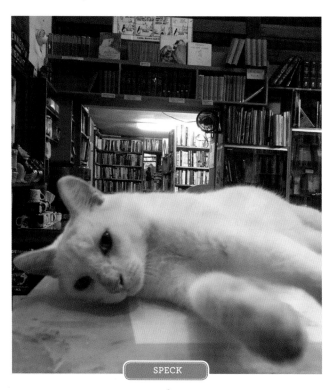

SPECK

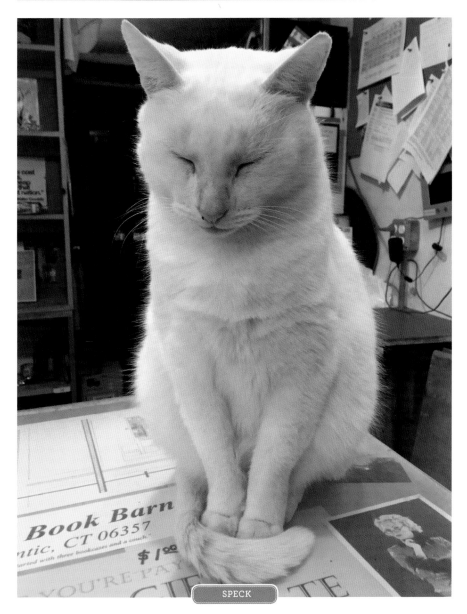

SPECK

Pipkin

Pipkin is the baby of the team, and his mischief more than makes up for his lack of years. Deceptively adorable in his orange and white coat, he's something of a menace to the local bird and rodent communities. He's very, very friendly, but he's picturing you as three inches tall and edible. If you catch him sleeping, looking so sweet and restful, go ahead—pet him. Now count your fingers!

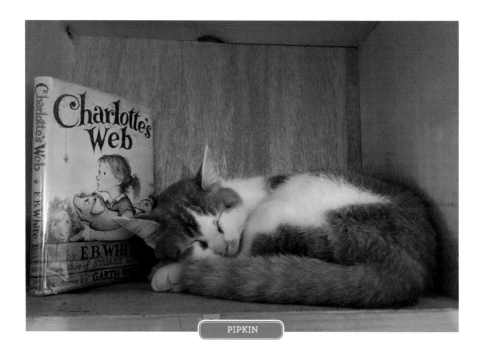

PIPKIN

CATS IN NONFICTION SERIES

Cleo

(*Cleo* by Helen Brown)

Norton

(*The Cat Who Went to Paris* by Peter Gethers)

Toby Jug

(*Paw Tracks in the Moonlight* by Denis O'Connor)

Thermal

(*The Cat Who Came in from the Cold* by Deric Longden)

Polar Bear

(*The Cat Who Came for Christmas* by Cleveland Amory)

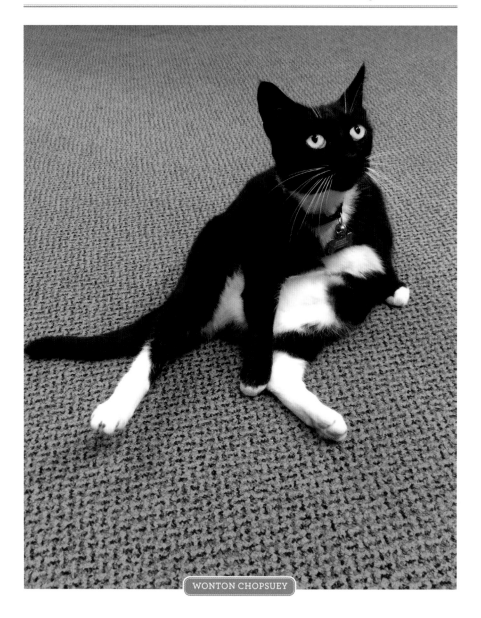

WONTON CHOPSUEY

WonTon ChopSuey

WonTon ChopSuey has been a full-time bookstore cat since 2008. He started dabbling in the business by coming through the back window of the store's original location and hanging out with the team during the day, accepting their love and food, but escaping out the window again before closing. After a few weeks, they decided he had adopted them, so they put a collar and tag on him to claim him as their own. The very next day, a neighbor came in with "Lost Cat" posters featuring WonTon (though strangely, they referred to him as "Lloyd"). After a few days of negotiations it was determined that WonTon preferred the literary life, and he has been with ChopSuey ever since. His hobbies include walking across the computer keyboard when humans are typing, ignoring customers who want to pet him, and demanding to be fed.

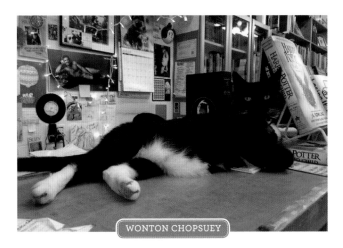

WONTON CHOPSUEY

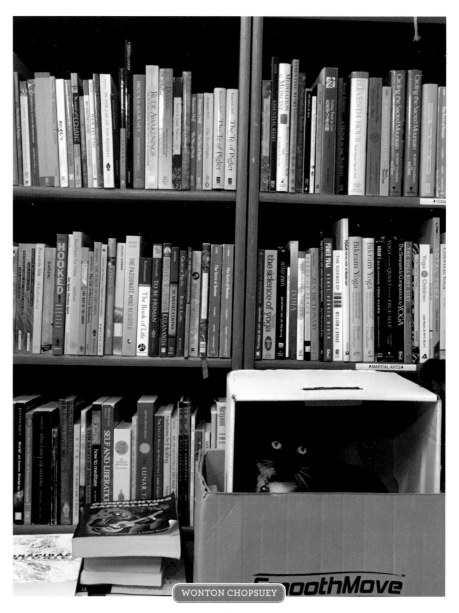

WONTON CHOPSUEY

CATS OWNED BY BRITISH AUTHORS

El Magnifico

(Doris Lessing)

Hinse

(Sir Walter Scott)

Jock

(Winston Churchill)

Bob

(Charles Dickens)

Taki

(Raymond Chandler)

The Owl and the Pussy-Cat

I

The Owl and the Pussy-cat went to sea
 In a beautiful pea-green boat,
They took some honey, and plenty of
 money,
 Wrapped up in a five-pound note.
The Owl looked up to the stars above,
 And sang to a small guitar,
"O lovely Pussy! O Pussy, my love,
 What a beautiful Pussy you are,
 You are,
 You are!
What a beautiful Pussy you are!"

II

Pussy said to the Owl, "You elegant fowl!
 How charmingly sweet you sing!
O let us be married! too long we have
 tarried:
 But what shall we do for a ring?"
They sailed away, for a year and a day,
 To the land where the Bong-Tree
 grows

And there in a wood a Piggy-wig stood
 With a ring at the end of his nose,
 His nose,
 His nose,
 With a ring at the end of his nose.

III

"Dear Pig, are you willing to sell for one
 shilling
 Your ring?" Said the Piggy, "I will."
So they took it away, and were married
 next day
 By the Turkey who lives on the hill.
They dined on mince, and slices of quince,
 Which they ate with a runcible spoon;
And hand in hand, on the edge of the
 sand,
 They danced by the light of the moon,
 The moon,
 The moon,
They danced by the light of the moon.

—Edward Lear

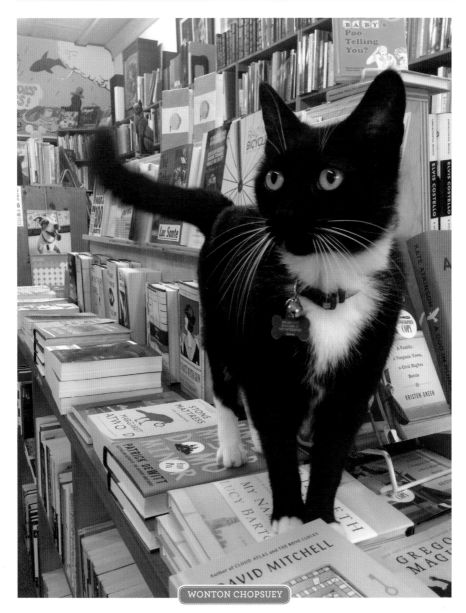

WONTON CHOPSUEY

Gatsby

When former shelter cat Gatsby isn't greeting customers with yowls and meows from his chair in The Book Man's front window, he can usually be found following them around the store, giving recommendations in exchange for attention. On slow days, he steals pens from the counter and bats them down the aisles, scales bookshelves for exercise, and snoozes . . . often. If you pop in during one of his catnaps, don't worry! He's happy to be awakened for treats and petting. According to the many devoted fans he's accrued over his six-year tenure at The Book Man, Gatsby's fur is extraordinarily soft and well worth a break from book browsing for a quick pet!

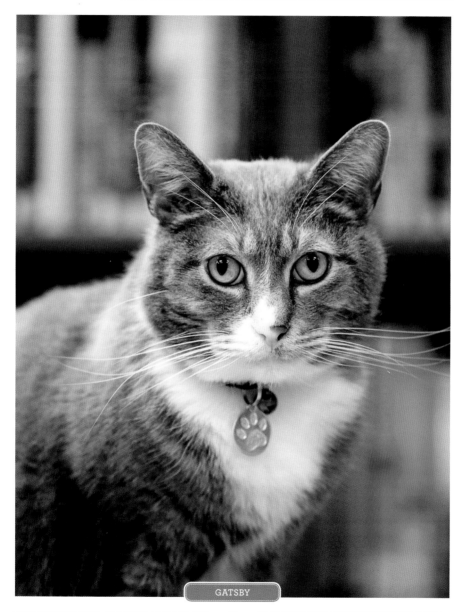

GATSBY

Cats Owned by Novelists

Snowball

(Ernest Hemingway)

Magnificat

(Philip K. Dick)

Sour Mash, Appollinaris, and Zoroaster

(Mark Twain)

Mysouff

(Alexandre Dumas)

Theodor W. Adorno

(Julio Cortázar)

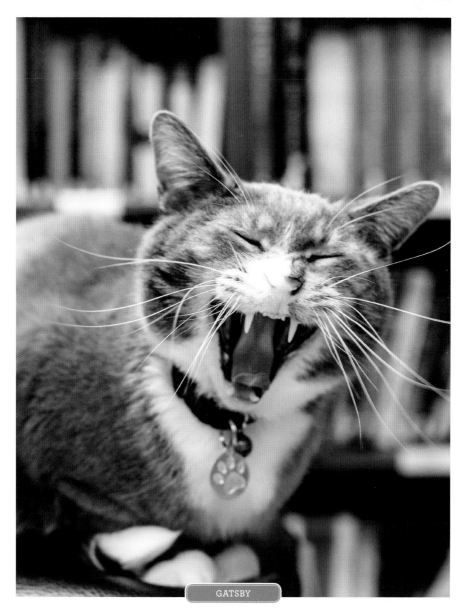

GATSBY

Nietzsche

The senior member of The Book Man's cat duo, Nietzsche has mastered the art of greeting customers as soon as they enter to welcome them to the store. The star of a cat calendar six years running, subject of plenty of media coverage, and proudly featured on book bags, bookmarks, and framed prints, you'd think celebrity would have gone to Nietzsche's head, but he prefers to keep his day job supervising transactions at The Book Man's front counter, testing the store's chairs for comfort, and humbly accepting the lavish attention heaped upon him by his legion of admirers.

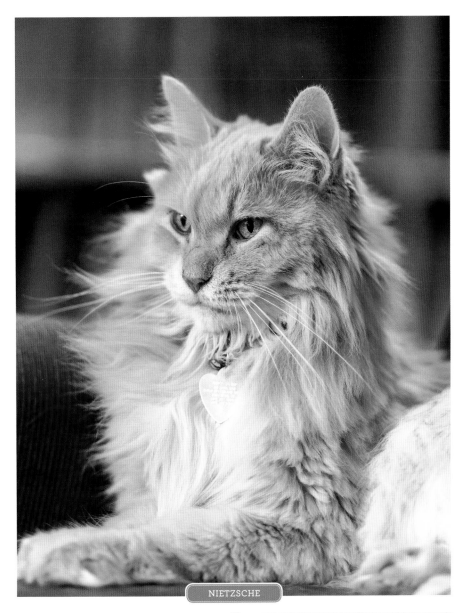

NIETZSCHE

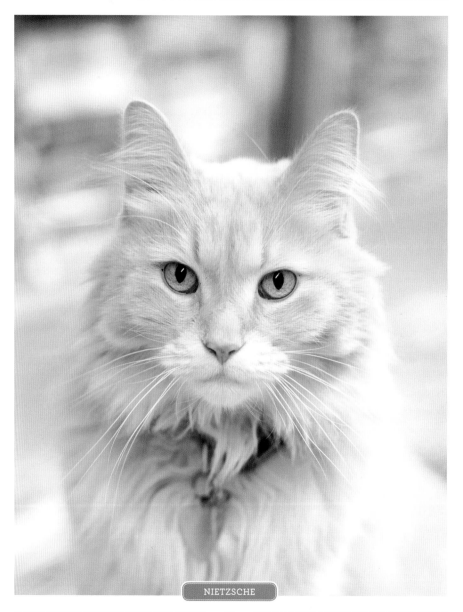

NIETZSCHE

CATS IN POETRY

Mr. Mistoffelees

(*Old Possum's Book of Practical Cats* by T. S. Eliot)

Cat

(*Weep Not for Me* by Constance Jenkins)

Pussy-Cat

by Spike Milligan

To Mrs Reynolds's Cat

by John Keats

Sterling

For nearly ten years, Sterling has been the face of Abraxas
Books. From the day he darted in front of owner James's car as
a terrified four-week-old kitten, the two have been inseparable.
Commuting back and forth from home to store each day, Sterling
spends most working hours on James's lap or shoulder like a
giant, furry parrot, occasionally patrolling the store to investigate
strange sounding (or smelling) customers. Sterling has a knack
for wooing customers and is especially skilled at calming the
difficult ones, but everyone has limits, and nothing enrages him
like a customer toppling a stack of his precious books! After all,
he's devoted his entire life to them (and James).

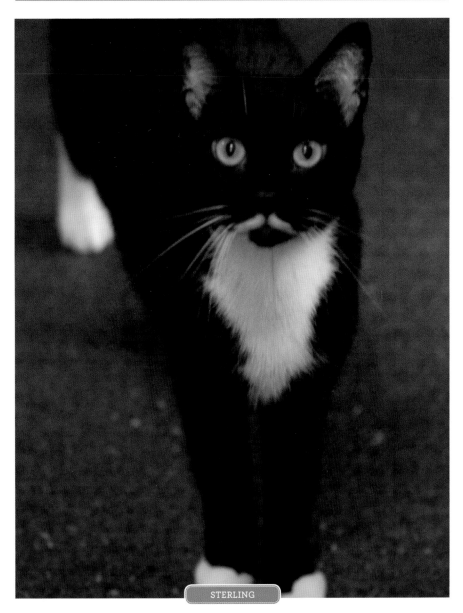

STERLING

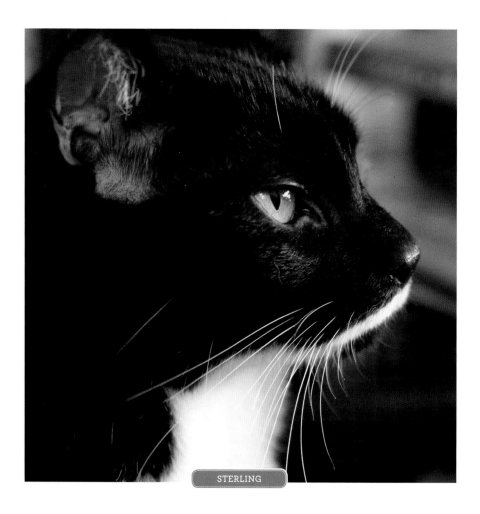

STERLING

CATS OWNED BY POETS

Foss

(Edward Lear)

Caterina

(Edgar Allan Poe)

Tyke

(Jack Kerouac)

Hodge

(Samuel Johnson)

Jellylorum

(T. S. Eliot)

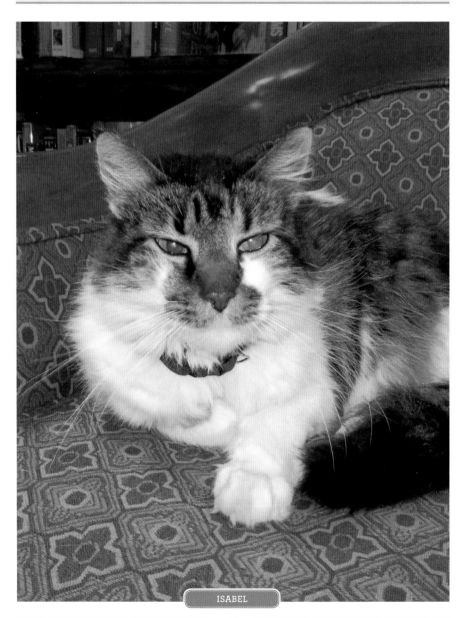

ISABEL

Isabel

Isabel, the sixteen-year-old bookshop cat at Crescent City
Books, was rescued from an animal shelter in Violet, Louisiana,
in 2011. Her owners, who most likely worked in the fishing
industry, abandoned her following the BP oil spill in spring 2010.
She is part Maine coon, which is what manager Michael Allen
Zell was seeking, as the breed is famous for its sweet and gentle
temperament. The animal shelter was located in an area settled
by the Los Isleños (Canary Islanders), who emigrated in the
late eighteenth century, so Michael wanted the cat to have a
Spanish name, and his wife enjoys the books of Isabel Allende,
so voilà!…the name was chosen. Isabel spends her days napping,
eating, and basking in attention, which has only increased since
her debut in the local press.

Atticus & Scout

Eight-year-old Atticus and six-year-old Scout are aptly named. He is a dignified, intelligent gentleman, while she is sweet, curious, and a little odd. Atticus is much better known in the store, both because he visits more often and because he's more social and cuddly. If you're sitting on the couch, chances are you'll have company before long. Scout is more elusive, but if you're browsing in the nonfiction section, she'll make sure to stop by and ask for treats. Atticus is also particularly fond of kids. He follows them around, letting them pet and play with him. Atticus is featured in the store's logo and is much more popular than anyone else in the store. Between patrols, he spends most of his time napping on his custom cushion, hand-sewn for him by one of the store's booksellers. When Scout is off duty, she's either lying in the treat drawer or napping in a secret location the store's human employees have yet to discover.

Atticus definitely rules the roost, but both kitties love the attention they get from staff and customers. Still, unlike most bookstore cats, Atticus and Finch tend to go home after work rather than spend the night. There, they develop their unique opinions and cultural interests, and hone other skills they hope to turn into second careers.

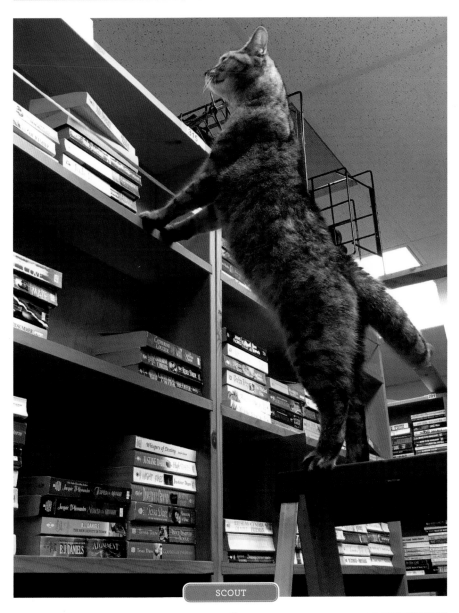

SCOUT

ATTICUS

Atticus likes chin scratches, kids, and chicken, but hates belly rubs, yappy dogs, and thunderstorms. His favorite author is Edgar Allan Poe, and he loves watching *Sherlock* on television. His dream job is quarterback for the Baltimore Ravens.

Scout likes birds, warm computers, and hot sauce, but does not enjoy manicures, ceiling fans, or the vacuum cleaner. Her favorite author is Maurice Sendak, and her favorite show is *Pinky and the Brain*. She plans to be the next spokesmeowdel for Whiskas.

ATTICUS

Tuffie Tufferton

Tuffie Tufferton has been at Crooked House Books & Paper
since before the store was even in existence. As the store's
official greeter, Tuffie takes many breaks from welcoming
customers to sleep in the warmest place she can find: In the
winter, look for her on a heat vent under a shelf; in the summer,
try a sunny patch on the front porch. At age fifteen, Tuffie shows
no signs of retiring, and still inspects all boxes and packing
materials for quality standards and cat approval as vigorously
as ever. In her downtime, she enjoys bird watching from
Crooked House's front window.

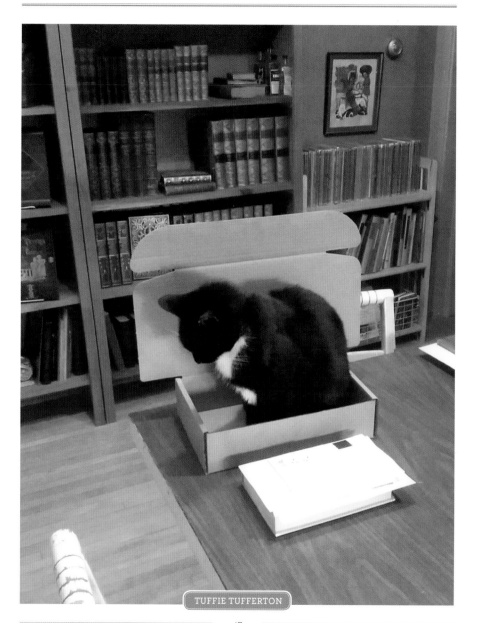

TUFFIE TUFFERTON

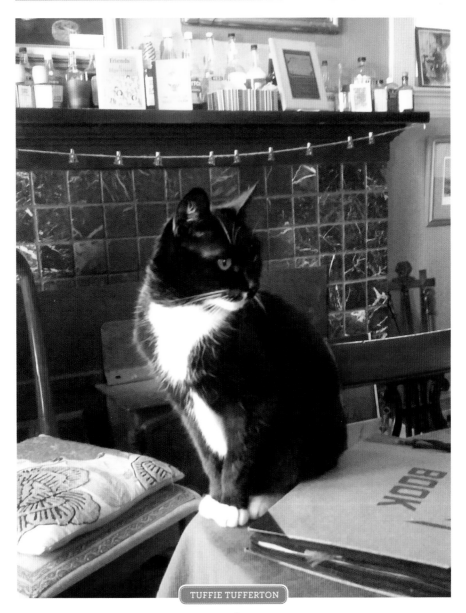

TUFFIE TUFFERTON

Cats in Horror Novels

Winston Churchill

(*Pet Sematary* by Stephen King)

Francis

(*Felidae* by Akif Pirinçci)

The Cat

(*Coraline* by Neil Gaiman)

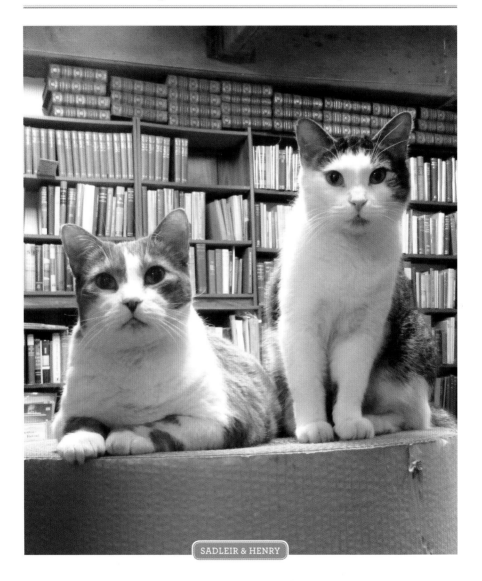

SADLEIR & HENRY

Sadleir & Henry

Sadleir came to David Mason Books by way of the Toronto
Humane Society, where he was called Bubba. Opting for more
refinement, he chose to name himself for bibliographer Michael
Sadleir, and thus began his career as chief mouser. In a lucky
break, it was determined that there were no mice on the premises,
and Sadleir was promoted to management, where he spends
most of his days lazing about in a cardboard box or schmoozing
the neighbors with diplomatic visits. Like all VIPs, Sadleir is
actively engaged in social media, but he also appreciates the
old-fashioned snail mail he receives from vacationing clients and
university libraries.

Henry arrived at David Mason Books three years after his colleague, Sadleir, when he was noticed in a nearby vet's window. A consummate cat-video addict, Henry spends too much time in front of computers, but he does take breaks to inspect the tops of bookcases and get into whatever mischief he can find. Unlike most cats, Henry is a big fan of tummy rubs! When not working, Henry cultivates his extensive paper ball collection, which he keeps carefully hidden under furniture throughout the store. His older brother, with whom he can sometimes be found conferencing in secret behind bookcases, is currently grooming Henry for management.

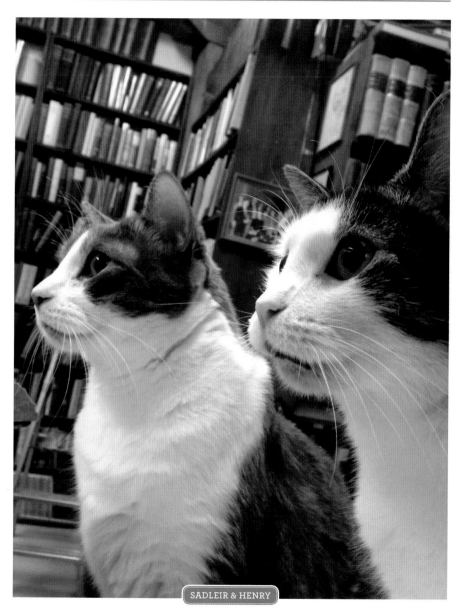

SADLEIR & HENRY

Cats in Comic Books

Garfield

(*Garfield*)

Krazy Kat

(*Krazy Kat*)

Heathcliff

(*Heathcliff*)

Hershey the Cat

(*Sonic the Hedgehog*)

Hobbes

(*Calvin and Hobbes*)

Simon's Cat

(*Simon's Cat* by Simon Tofield)

Misty

(*Cat Getting Out of a Bag* by Jeffrey Brown)

Cat

(*Cat Versus Human* by Yasmine Surovec)

Jimmy

(*Cat Person* by Seo Kim)

Chi

(*Chi's Sweet Home* by Kanata Konami)

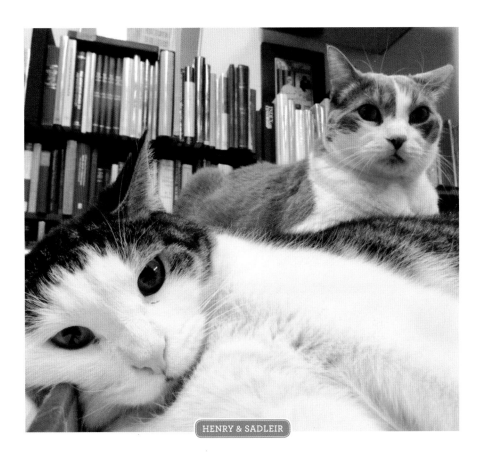

HENRY & SADLEIR

She Sights a Bird—She Chuckles

She sights a Bird—she chuckles—
She flattens—then she crawls—
She runs without the look of feet—
Her eyes increase to Balls—

Her Jaws stir—twitching—hungry—
Her Teeth can hardly stand—
She leaps, but Robin leaped the first—
Ah, Pussy, of the Sand,

The Hopes so juicy ripening—
You almost bathed your Tongue—
When Bliss disclosed a hundred Toes—
And fled with every one—

—Emily Dickinson

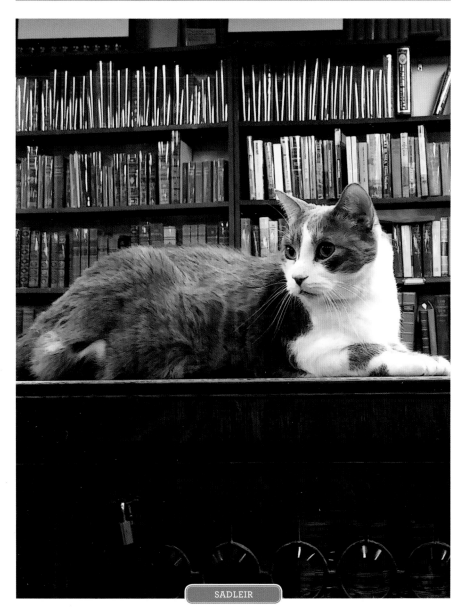

SADLEIR

Lucy

Twenty-one-year-old Lucy is surely descended from royalty and has not forgotten that her blood runs blue. She considers herself the owner of Hearthfire Books, where she took up permanent residence after disapproving of a new roommate at home. Lucy loves to greet new customers (perhaps too enthusiastically at times!) and is endlessly patient with the many children who fawn on her, but she draws the line at being kind to visiting dogs. She may be old, but her spirit is young and her voice is loud, especially when it's time for her meals to be served! For seven years Lucy has been attempting to infiltrate the food/treat section of Hearthfire Books, but she has yet to succeed. Her mom (and store owner), Kappy Kling, says that Lucy's energy and quirkiness help the store function at high levels of exuberant positivity.

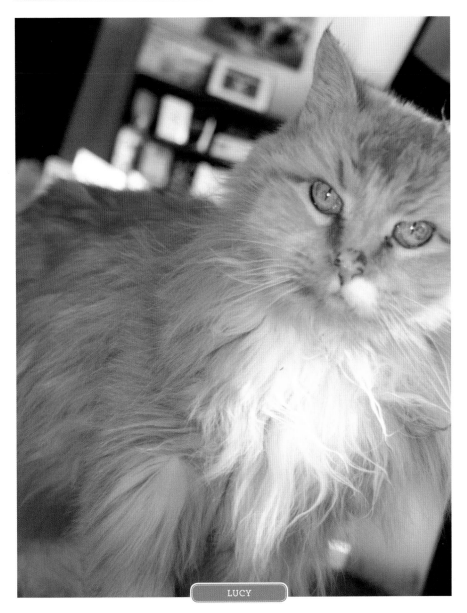

LUCY

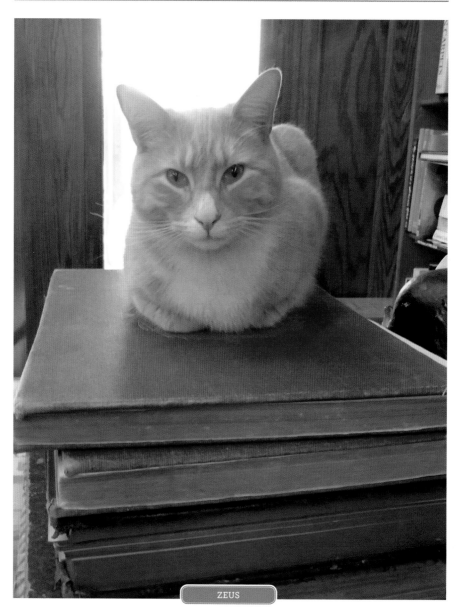

ZEUS

Zeus & Apollo

Iliad Bookshop adopted Zeus and Apollo after a homeless
man's cat gave birth to them, and they instantly took a liking to
bookstore cat life, serving as brand ambassadors. They're very
sociable and don't mind being petted almost constantly, even
in their sleep! Zeus is the feistier of the two; Apollo, on the other
hand, likes laps and sometimes crawls onto a seated customer's.
They love the tall ladders around the store and are very skilled
at running up and down them, occasionally leaping from the
ladders onto the backs of passing customers (so far, no one has
objected!) and riding around for a while. They have a love-hate
relationship with dogs that visit the store—Zeus will sometimes
stalk a smaller dog, but they're both unnerved by larger breeds.

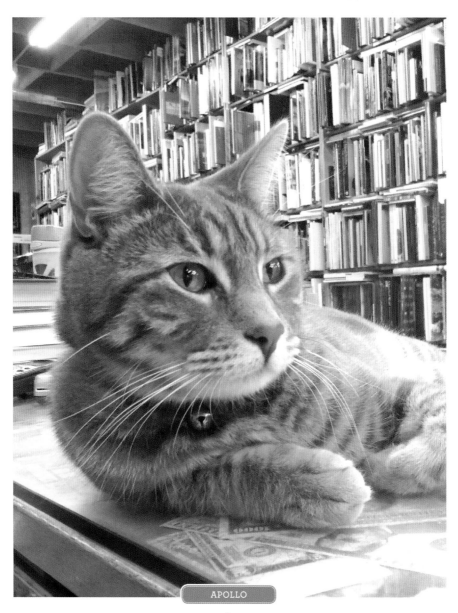

APOLLO

They're possibly the most adored and photographed cats in North Hollywood: A customer's photo of Apollo received more than 100,000 views on Tumblr, and the brothers have no plans to leave their high-profile careers behind anytime soon. Like all celebrities, they need some time to rest, too: Apollo prefers to nap behind the monitors on the sales desk, and Zeus's personal hangout is a stack of boxes in the rear corner of the store.

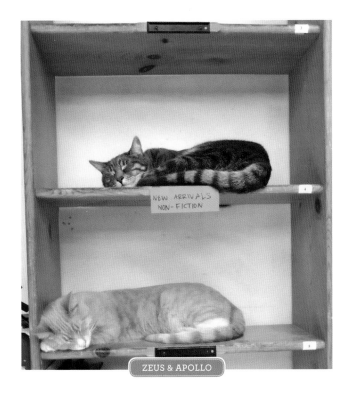

NEW ARRIVALS
NON-FICTION

ZEUS & APOLLO

Huckleberry & Finn

From My Shelf Books & Gifts has high standards for its feline employees, and Huckleberry and Finn fit the bill. Social, gentle, loving, and a bit goofy, these three-year-old brothers came to the store after a vacancy left by Hobo, an ace (cat) employee of nearly eight years who left behind big paws to fill. The store hosted many cats and dogs from the local branch of the Animal Care Sanctuary to help them socialize and meet new families, but none of the visiting animals became permanent until Huck and Finn came on the scene. Their names were selected through a contest seeking literary names that also highlighted their loving, eccentric personalities. These days, Huck pals around with dad and store owner, Kevin Coolidge, supervising the store and taking a more active role in the family business, while Finn spends most of his time refining the art of the nap.

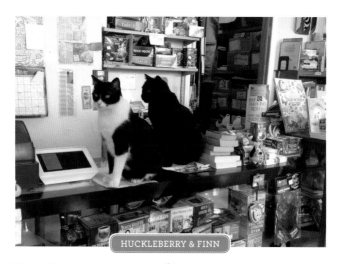

HUCKLEBERRY & FINN

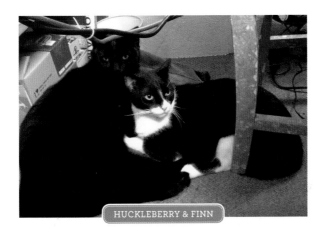

HUCKLEBERRY & FINN

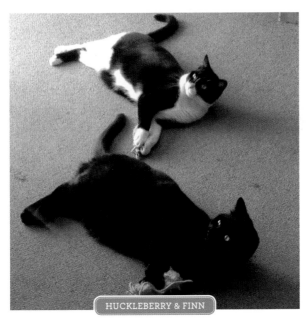

HUCKLEBERRY & FINN

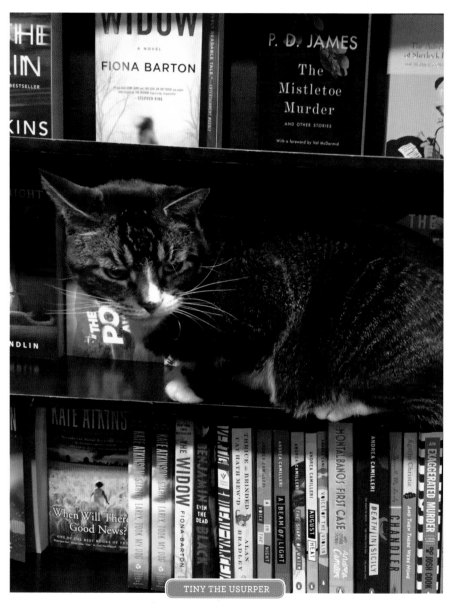

TINY THE USURPER

Tiny the Usurper

The runt of the litter, born on the street and left on a doorstep, Tiny has come a long way from his humble origins. Now the self-professed owner of Community Bookstore, Tiny's social media following is always growing, and he's huge in Japan, where he graced the cover of a best-seller and has been featured on television (he still receives visits from Japanese tourists seeking the famous New York shop cat!). Despite his career as a celebrity, Tiny still prefers the slow life, napping in warm, comfy spots and focusing primarily on food during his waking hours. He occasionally takes time to greet fans, but be warned: nosy dogs and excitable children aren't his faves. In fact, he's earned a rep as "that grouchy cat" in his neighborhood, but that hasn't stopped his admirers from visiting regularly!

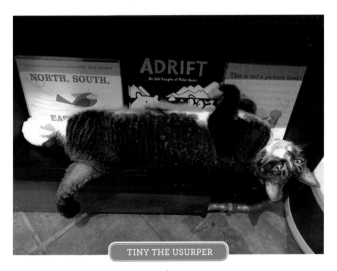

TINY THE USURPER

Cats in Science-Fiction Novels

Petronius the Arbiter

(*The Door into Summer*
by Robert A. Heinlein)

Mort(e)

(*Mort(e)* by Robert Repino)

Tuf's Cat

(*Tuf Voyaging*
by George R. R. Martin)

Mickey

(*Barbary* by Vonda N. McIntyre)

Master Ren

(*Monstress* by Marjorie Liu
and Sana Takeda)

Lying Cat

(*Saga* by Brian K. Vaughan
and Fiona Staples)

Nimitz

(*The Honorverse* by David Weber)

The Cats of Ulthar

(*The Cats of Ulthar*
by H. P. Lovecraft)

Strig Feleedus

(*Angel Catbird*
by Margaret Atwood)

Lucky

(*The Green Millennium*
by Fritz Leiber)

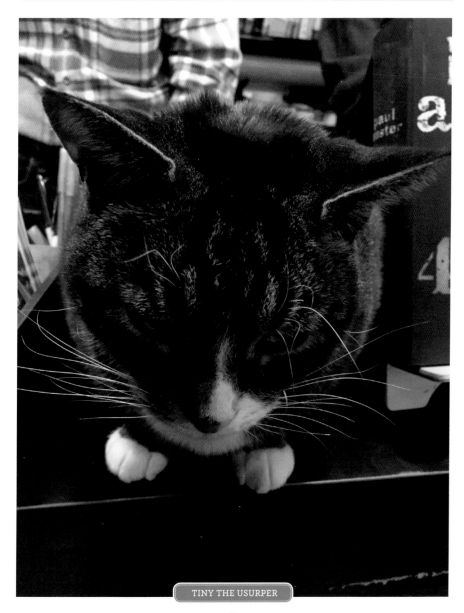

TINY THE USURPER

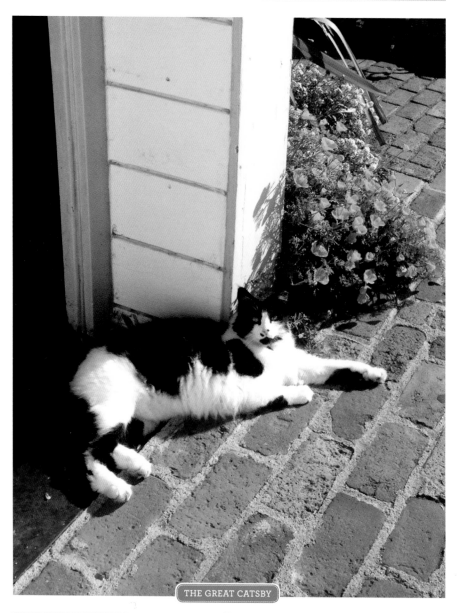

THE GREAT CATSBY

The Great Catsby

The Great Catsby joined the Gallery Bookshop team in 2012 after deciding he needed a life change. He had previously been squandering his days wandering the streets of a neighboring town, darting in and out of random businesses. One day, he found a car with an open window and hitchhiked (without the driver's knowledge) to the village of Mendocino. There, he was picked up by a friend of the bookshop and offered the job of bookstore cat. His duties include sleeping atop card racks, greeting dogs with a glare and a flick of his tail, and occasionally allowing customers to scratch him behind the ears. Like many a seasoned shop cat, he can usually be found sitting in the window, warming himself in a patch of sunlight.

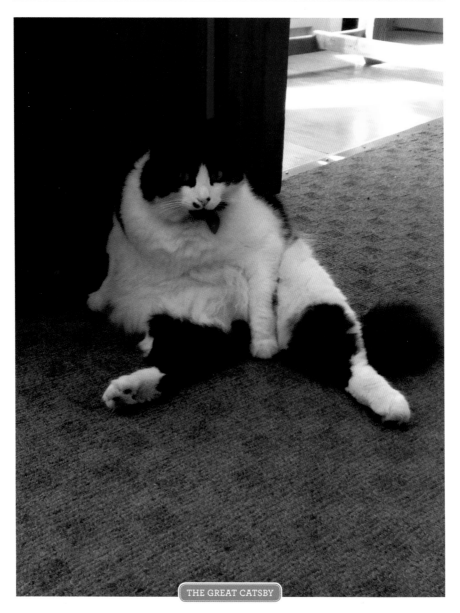

THE GREAT CATSBY

Cats in Nonfiction

Dewey

(*Dewey* by Vicki Myron)

Homer

(*Homer's Odyssey*
by Gwen Cooper)

Oscar

(*Making Rounds with Oscar*
by David Dosa)

Spit

(*My Cat Spit McGee*
by Willie Morris)

Casper

(*Casper the Commuting Cat*
by Susan Finden)

Ben

(*The Cat Who Came Back for
Christmas* by Julia Romp)

Sugeih

(*Cats in the Belfry*
by Doreen Tovey)

Ernie

(*Ernie* by Tony Mendoza)

Maru

(*I Am Maru* by Mugumogu)

Frannie

(*Kitty Cornered* by Bob Tarte)

Rudie,
Rosita Slice-A-Pizza & Boba Wilbur Bumpus

At eighteen years old, Rudie refuses to retire but has no qualms about spending most of the day napping. Her primary concern is making sure her bubble-wrap-filled cardboard box is positioned by her preferred radiator in the children's section, and complaining when it's not, rebuking the luxury cat bed she's been offered. She occasionally gets up in search of snacks but otherwise carefully supervises the children in her department, accepting head scratches and delighting the little ones.

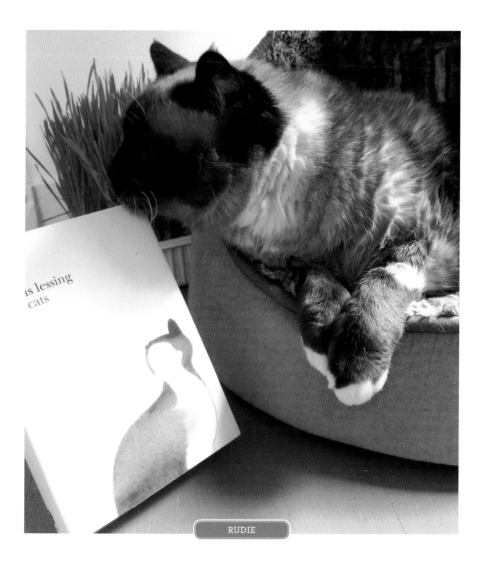

RUDIE

Boba and Rose, still kittens, are the newest arrivals to Postmark Books, and they have a little more energy (which isn't always good!) than does the veteran Rudie. While Rose stalks customers from the tops of the bookcases, Boba does his best to knock over book displays in search of affection from every human who walks by. Each one has territorial quirks when it comes to the most important responsibility: napping. Rose must have a particular fuzzy laptop case set in a certain spot on the counter, while Boba has claimed the cat bed that Rudie shunned (and hoards his toys there). As long as all of these workstations are in place, the cats deliver hours of mostly incident-free hard work entertaining their fans.

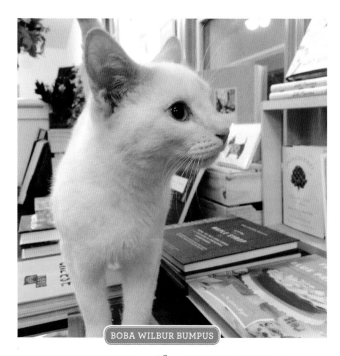

BOBA WILBUR BUMPUS

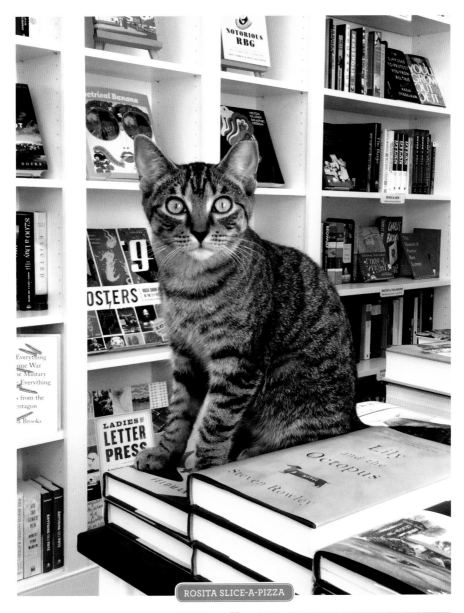

ROSITA SLICE-A-PIZZA

Ender & Emma

Six-year-old siblings Ender and Emma were adopted from a local shelter and have spent their lives dutifully making Recycle Bookstore a comfy home not just for themselves, but also for their customers. Store owner and self-appointed cat servant Eric Johnson has noticed how much his customers appreciate the cozy atmosphere of Recycle, and he praises Ender's and Emma's dedication to enhancing that at-home feel. Before looking for books, most regulars inquire first about the cats, or go right to their usual haunts (most often a special platform just above the register and below the heater!). Ender's a bit shy, usually napping or getting into mischief behind the counter, but Emma socializes enough for both of them, hunting down customers and taking a seat in their laps.

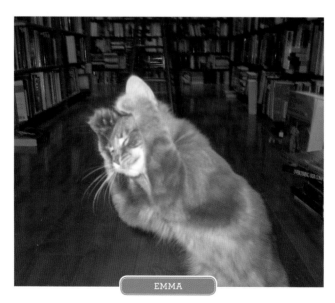

EMMA

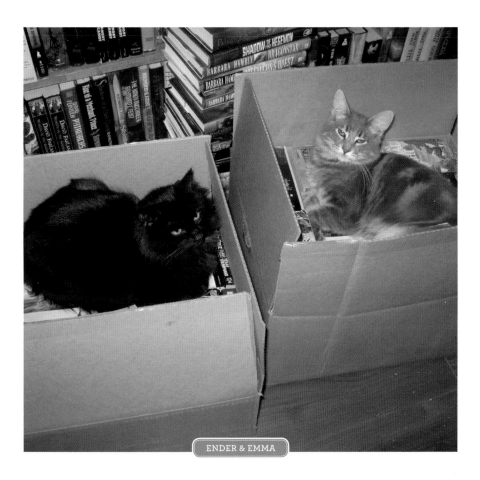

ENDER & EMMA

Cats in Short Stories

Pluto

(*The Black Cat* by Edgar Allan Poe)

Cat

(*The Rats in the Walls* by H. P. Lovecraft)

Captain Wow and Lady May

(*The Game of Rat and Dragon* by Cordwainer Smith)

Cat

(*Edward the Conqueror* by Roald Dahl)

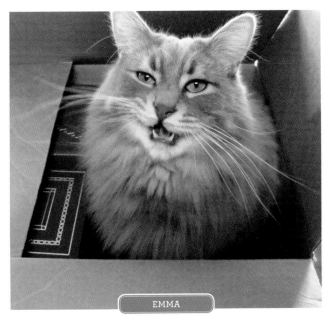

EMMA

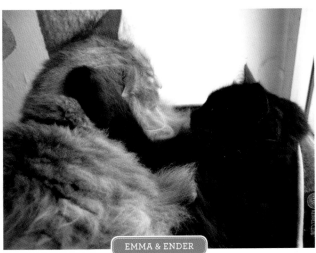

EMMA & ENDER

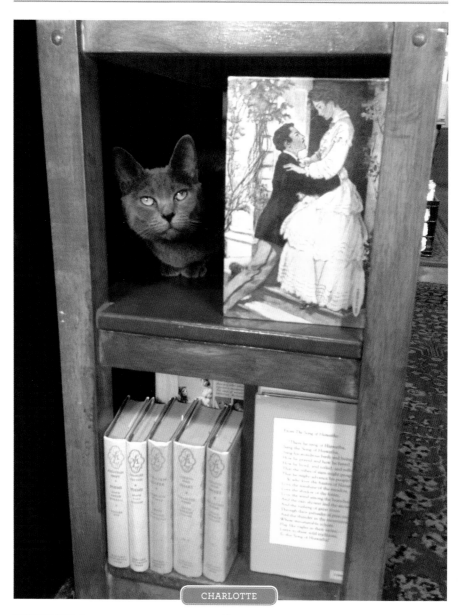

CHARLOTTE

Charlotte

Six years ago, Charlotte was a kitten attempting to cross a four-lane highway until the good folks at Rhino Booksellers rescued her and offered her a job as a bookstore cat. Her intense green eyes, soft coat, and petite frame made her an instant hit with the human staff, but it took Charlotte quite some time to warm up to them. Today, she's a crowd pleaser, happy to chat with customers/fans between explorations and chasing sunbeams. Her greatest skill is assessing boxes of used books brought in by one of her customers—she knows exactly which will lend themselves best to amazing future naps. A true Nashville girl, Charlotte loves guitar music and can't resist rubbing her face against the guitar and licking the strings whenever someone starts to play. Her coworkers and customers like her for her mouse- and bug-hunting skills and love her for the joy she brings to the shop.

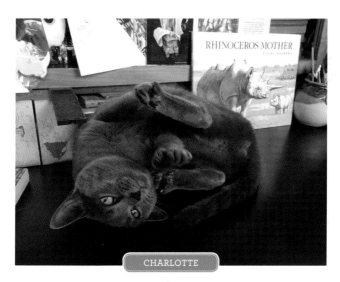

CHARLOTTE

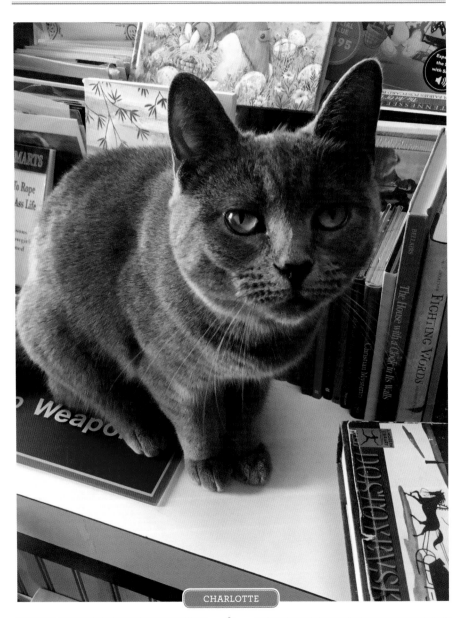

CHARLOTTE

Cats in Japanese Literature

Nakata

(*Kafka on the Shore* by Haruki Murakami)

Cat

(*I Am a Cat* by Soseki Natsume)

Noboru Wataya

(*The Wind-Up Bird Chronicle* by Haruki Murakami)

Cat

(*The Guest Cat* by Takashi Hiraide)

Cat

(*A Cat, a Man, and Two Women* by Jun'ichiro Tanizaki)

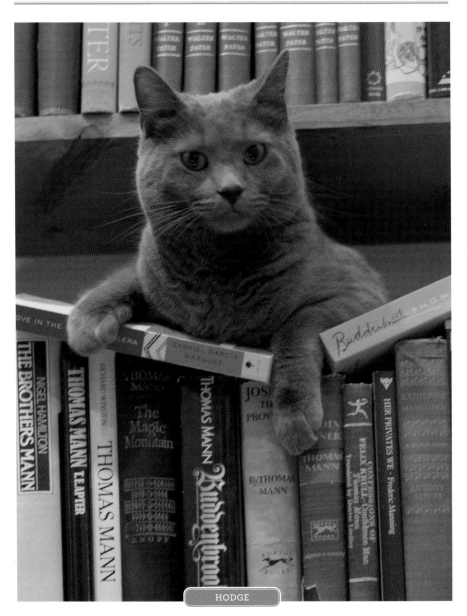

HODGE

Hodge

Chicago's most famous cat, Hodge is the subject of his very own book and has earned Selected Works the honor of Best Bookstore with a Cat by the *Chicago Reader*. Hodge has called the store home since he was a kitten, quickly learning to startle unsuspecting customers by zooming up the store's ladders to make recommendations, or to find exciting new adventures atop bookshelves. Beautiful, smart, and playful from the start, Hodge has been adding to his fan base for years and today receives more visitors than anyone else at Selected Works. If you can't find him when you stop by, check the top of the very tall bookcase behind owner Keith Peterson's desk, where Hodge is likely to be on lookout, scanning the shop for shenanigans.

To a Cat

Stately, kindly, lordly friend,
Condescend
Here to sit by me, and turn
Glorious eyes that smile and burn,
Golden eyes, love's lustrous meed,
On the golden page I read.

All your wondrous wealth of hair,
Dark and fair,
Silken-shaggy, soft and bright
As the clouds and beams of night
Pays my reverent hand's caress
Back with friendlier gentleness.

Dogs may fawn on all and some
As they come;
You, a friend of loftier mind,
Answer friends alone in kind.
Just your foot upon my hand
Softly bids it understand.

—Algernon Swinburne

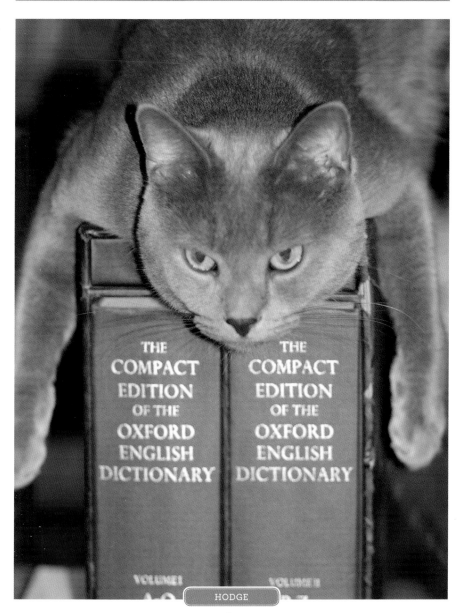

HODGE

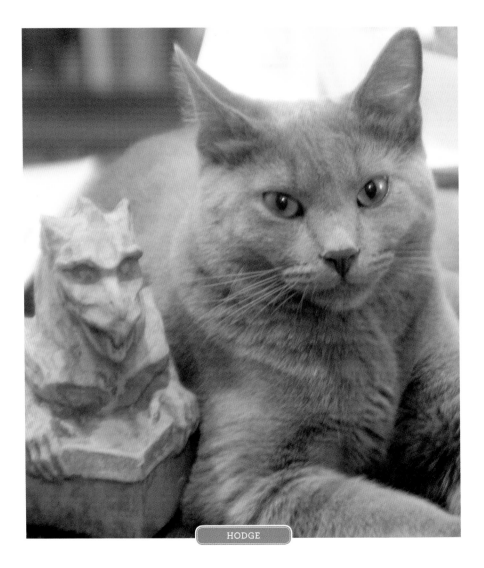

HODGE

CATS IN NEWBERRY HONOR BOOKS

Harry Cat

(*The Cricket in Times Square* by George Selden, 1961)

Cat

(*It's Like This, Cat* by Emily Cheney Neville, 1964)

Blue Kitten

(*The Blue Cat of Castle Town* by Catherine Coblentz, 1950)

Cat

(*One-Eyed Cat* by Paula Fox, 1985)

Amelia

Throngs of adoring fans aren't rare in the bookstore cat community, but not many of those felines can claim their own holiday. Coinciding with Independent Bookstore Day, Spiral Bookcase celebrates Amelia Cat Day annually. And why not? Amelia has not only been called Best Bookstore Cat of 2014 in one contest and her imagery has appeared on accessories, but her fans actually line up for a turn to pet her in her favorite worn-out chair in the store's reading room, the Parlor of Peculiarities.

Life's not all catnip and back scratches for this devoted bookstore cat, though: Amelia suffers from feline hyperthyroidism and requires a good bit of medical care, testing, and medication. Thankfully her devoted customers generously donate to Amelia's Medical Fund in appreciation for the cuddles and comfort she provides to the store's many visitors!

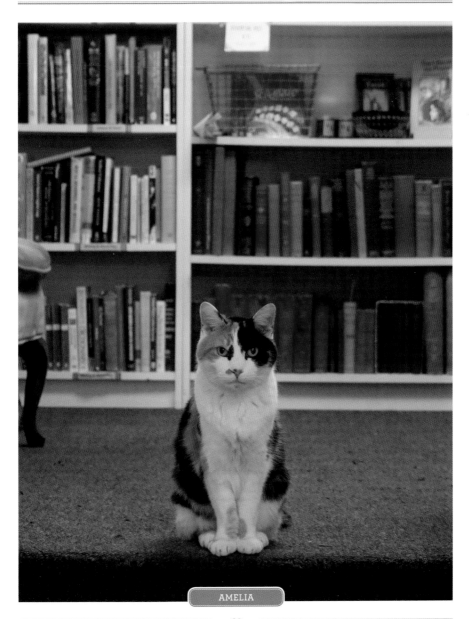

AMELIA

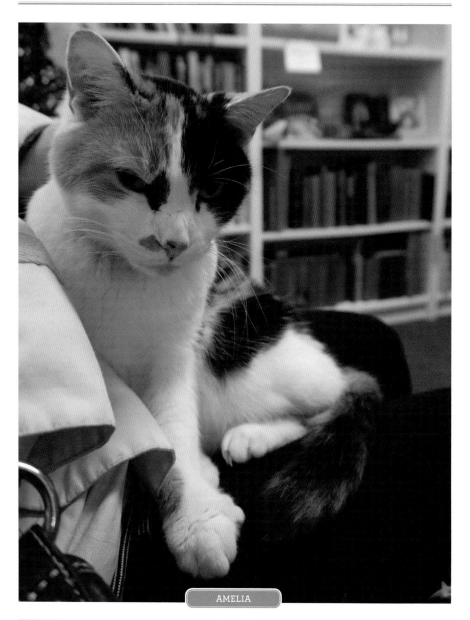

AMELIA

Verses on a Cat

A cat in distress,
Nothing more, nor less;
Good folks, I must faithfully tell ye,
As I am a sinner,
It waits for somne dinner
To stuff out its own little belly.

You would not easily guess
All the modes of distress
Which torture the tenants of earth;
And the various evils,
Which like so many devils,
Attend the poor souls from their birth.

Some a living require,
And others desire
An old fellow out of the way;

And which is the best
I leave to be guessed,
For I cannot pretend to say.

One wants society,
Another variety,
Others a tranquil life;
Some want food.
Others, as good,
Only want a wife.

But this poor little cat
Only wanted a rat,
To stuff its own little maw;
And it were as good
Some people had such food,
To make them hold their jaw.

—Percy Bysshe Shelley

CATS IN YOUNG ADULT SERIES

Buttercup

(*The Hunger Games*
by Suzanne Collins)

Small Bob

(*House of Hades* by Rick Riordan)

Crookshanks

(*Harry Potter* by J. K. Rowling)

Blacksad

(*Blacksad* by Juan Díaz Canales)

Rusty

(*Into the Wild* by Erin Hunter)

Tag

(*The Wild Road* by Gabriel King)

Mati

(*The Tygrine Cat* by Inbali Iserles)

Varjak Paw

(*Varjak Paw* by S. F. Said)

Rhiow

(*The Book of Night with Moon*
by Diane Duane)

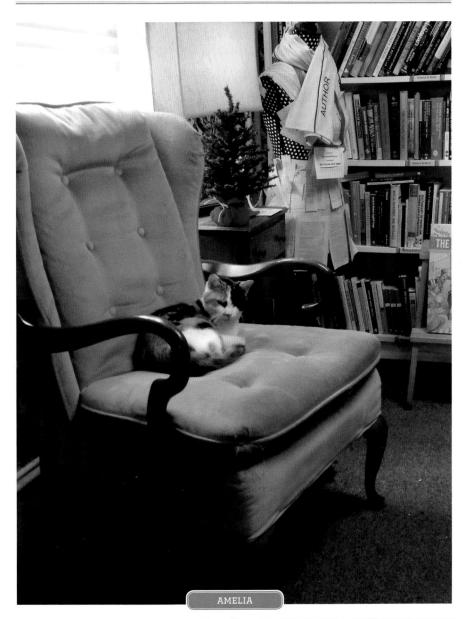

AMELIA

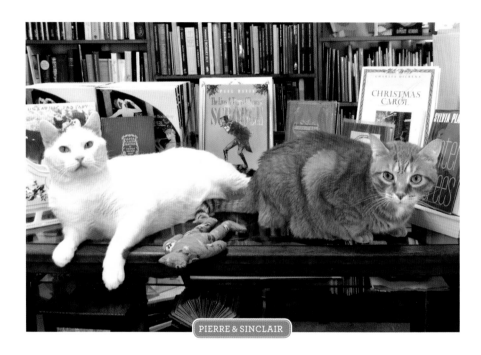

PIERRE & SINCLAIR

Pierre & Sinclair

Sinclair is the official greeter of The Kelmscott Bookshop, reaching the front door to welcome each customer before any human staff has a chance. Customer service doesn't stop with "hello," though, and Sinclair dutifully follows customers, providing recommendations in the form of friendly swats. Pierre is not as confident making suggestions yet, but he shadows Sinclair closely and is working up the courage to emulate his mentor someday. In the meantime, he spends a good bit of his day contemplating his career from the back office, peering out the window while Sinclair covers the front desk, chatting with customers and occasionally offering a painless nip from his mostly toothless mouth!

Both boys were rescued from rough circumstances: Pierre was a feral alley cat who was eventually coaxed into veterinary care and adoption by the bookshop, and Sinclair was found abandoned in an employee's apartment building. Today, the adoptive brothers celebrate five years of gainful employment at The Kelmscott Bookshop, where they are well loved and much appreciated!

Ngaio & Dashiell

Ngaio and Dashiell came to The Raven Book Store in 2011 from the Lawrence Humane Society. A naming contest ensued, and as the store has long specialized in mysteries, Ngaio was named for the classic New Zealand mystery maven, Ngaio Marsh. Dashiell, of course, is the namesake of Dashiell Hammett. The cats settled into their new names and home fairly quickly.

Ngaio is a very dainty, petite girl, but she's the ruler of the roost even though Dashiell is larger and more active. She sleeps a lot during the day, but she usually comes out in the evening and stands at the front door calling to people walking by, masterfully enticing customers into the store. Ngaio doesn't like being lifted, but she's quite likely to jump into an inviting lap. During author readings, she walks around collecting compliments and carefully checking out all of the guests until she finds the most desirable lap on which to perch comfortably.

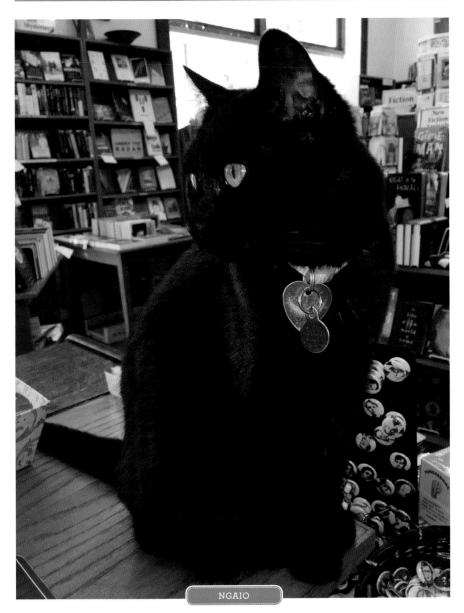

NGAIO

Dash is a big lumbering gray tabby with a funny cat smile and crinkly eyes. He likes to lounge on the counter and greet customers—who are usually surprised by his girth. He loves to eat. Sometimes Ngaio has to bop him on the head to remind him that she needs access to the food bowl, too! Dashiell talks a great deal and sometimes reaches up to tap the store clerks on the leg to get their attention. He is very affectionate and loves chewing people's hair if he gets the chance.

The cats have their own cat condo tower in the window of the store, and they can often be found sprawled out on the shelves watching the street. In warmer weather, look for them by the open door, beckoning customers, or napping on the bench in the sunshine out front—the one with their likenesses painted on it! Dashiell and Ngaio are very popular at The Raven Book Store and take their job as book ambassadors very seriously.

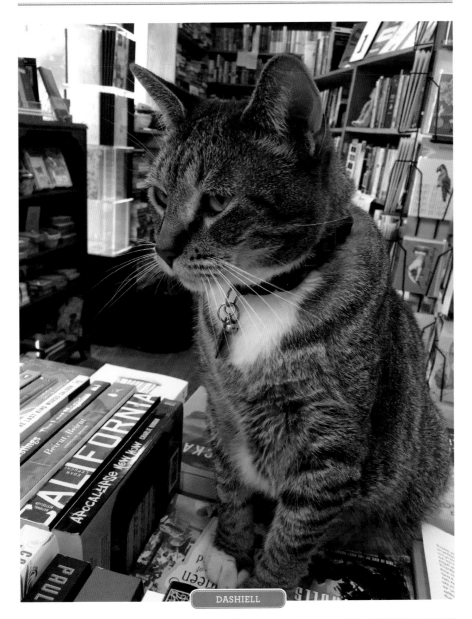

DASHIELL

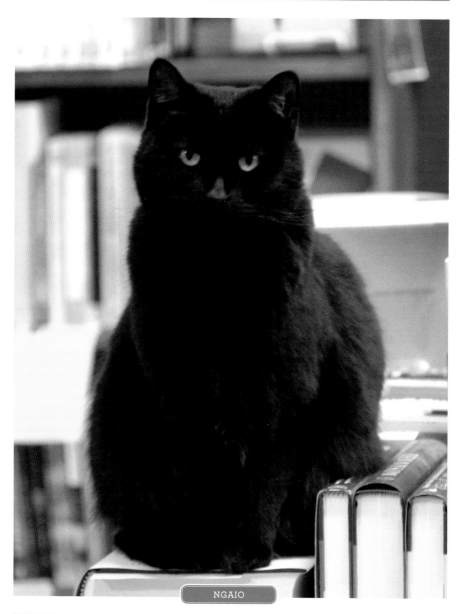

NGAIO

CATS IN LEGENDS

Cactus Cat

(American Southwest)

Cath Palug

(French and Welsh)

Dawon

(Tibetan)

Hombre Gato, or Catman

(Argentinian)

Kilkenny Cat

(Irish)

Bakeneko

(Japanese)

Manticore

(Persian)

Matagot

(French)

Pard

(Medieval)

Shisa

(Ryukyuan)

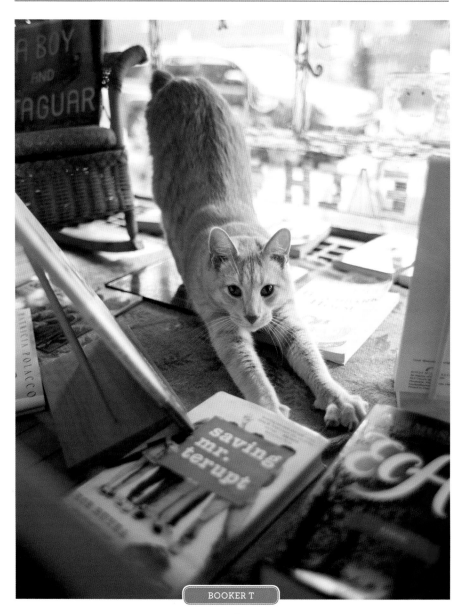

BOOKER T

Trini Lopez, Booker T & Walter Dean

This trio play a vital role in the animal kingdom that is Wild Rumpus. While they are not the only four-legged or furry animal employees, they are the most social. Contrary to popular belief, these felines did not lose their tails to slamming doors or grabby toddlers—they are Manx cats, a tailless breed that hails from the Isle of Man. Each of these well-read cats has his own personality, naturally: Trini Lopez, the oldest by far, is shy but sweet; Booker T is silly (if you enter with a baby stroller, you are likely to find a stowaway on your way out!); and Walter Dean is the friendliest rascal around.

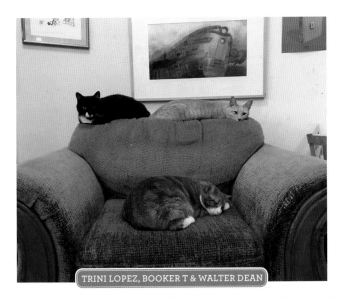

TRINI LOPEZ, BOOKER T & WALTER DEAN

Each of the rescue kitties was adopted in kittenhood from varying circumstances, and all have adapted well to the great demands of bookstore cat life, particularly the skill of locating the ideal napping environment. Trini Lopez loves the stack of bags under the front counter; Booker T opts for baby strollers, a child's rocking chair, or boxes of recycled paper; and Walter Dean plays it safe with the front window or a cat bed behind the counter.

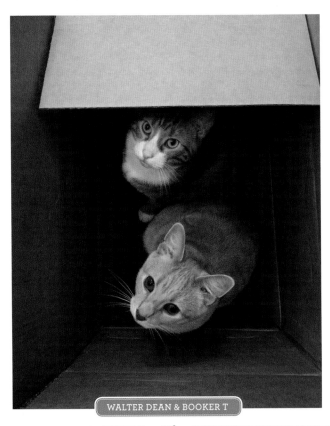

WALTER DEAN & BOOKER T

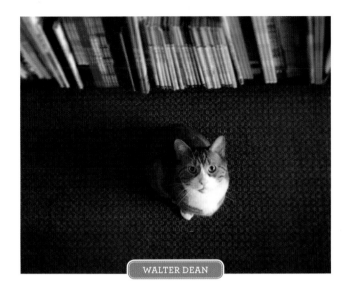

WALTER DEAN

Fog

The fog comes
on little cat feet.

It sits looking
over harbor and city
on silent haunches
and then moves on.

—Carl Sandburg

Cats in Young Adult Books

Kichibo

(*Tomorrow's Sphinx* by Clare Bell)

Fritti Tailchaser

(*Tailchaser's Song*
by Tad Williams)

Pete

(*Spy Cat* by Peg Kehret)

Gareth

(*Time Cat* by Lloyd Alexander)

Diesel

(*Arsenic and Old Books*
by Miranda James)

Mogget

(*Sabriel* by Garth Nix)

Marco

(*Guardian Cats* by
Rahma Krambo)

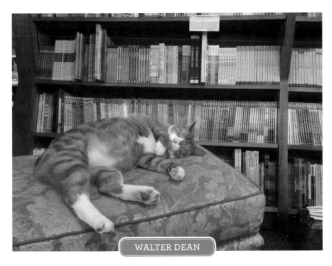

WALTER DEAN

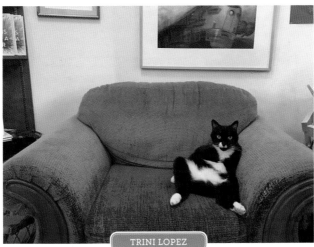

TRINI LOPEZ

ABC

Great A, little a,

Bouncing B!

The cat's in the cupboard,

And can't see me.

—Mother Goose

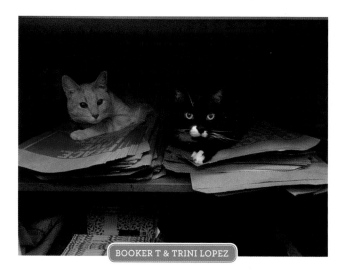

BOOKER T & TRINI LOPEZ

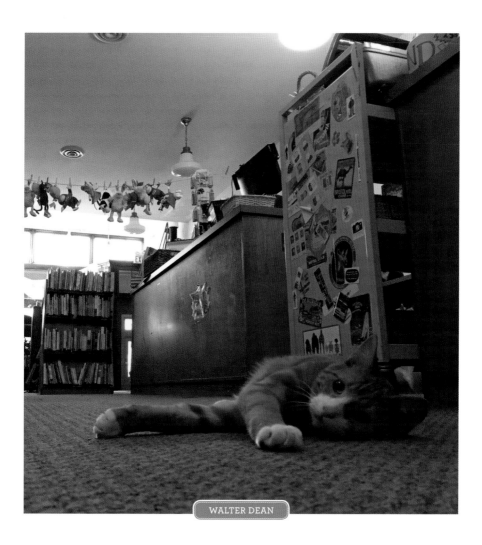

WALTER DEAN

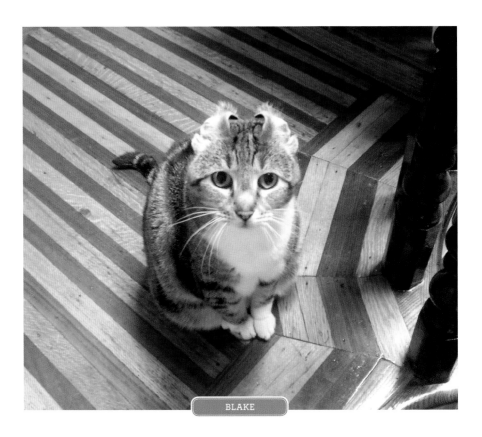

BLAKE

Blake

Blake adopted her human family after meeting two of them at the Philadelphia Animal Welfare Society (PAWS) in 2011 and immediately installed herself as hostess of Philadelphia Rare Books & Manuscripts Company. While she's kind to all guests, she's a bit more discerning than a typical greeter and changes her mind about some customers mid-approach.

Somehow, unbeknownst to her human coworkers, Blake has cultivated an impressive media presence, garnering plenty of interviews for herself, including a prized feature in *Cat Fancy* magazine. Since finding fame, Blake has experimented with new looks, and recently has taken to stylizing her ears in the fashion of a Scottish fold (pictured here), though she isn't one! To Blake, it's not what you're born with, it's what you make of it, and she's made an excellent life for herself as a popular bookstore cat.

Cats in Children's Books

Cheshire Cat

(*Alice's Adventures in Wonderland*
by Lewis Carroll)

Aslan

(*The Chronicles of Narnia* by
C. S. Lewis)

The Cowardly Lion

(*The Wonderful Wizard of Oz* by
L. Frank Baum)

Aristotle

(*The Nine Lives of Aristotle*
by Dick King-Smith)

Socks

(*Socks* by Beverly Cleary)

Moses

(*Moses the Kitten*
by James Herriot)

Pickle

(*The Little Kitten* by Judy Dunn)

Cat

(*The Cat Who Went to Heaven*
by Elizabeth Coatsworth)

Jennie

(*Jennie* by Paul Gallico)

Dragon

(*Mrs. Frisby and the Rats of NIMH*
by Robert C. O'Brien)

Shina

Seven-year-old Shiva is at the head of what may be the largest feline bookselling workforce in the world! Cat Tales is a bookstore operated by Midwest Pet Refuge to help fund the rescue and bring exposure to the "team," assisting in locating permanent homes for retirement. With up to fifteen cats in residence at a time, most run free throughout the store, creating enticing window displays (of themselves!), testing the weight and durability of books, and competing for customers' attention. Shiva mostly prefers to use books as pillows, but she occasionally chips in by helping manager Tara Drumm with the not-for-profit's tireless mission of taking in stray and unwanted cats, coordinating veterinary treatment, and getting them adopted.

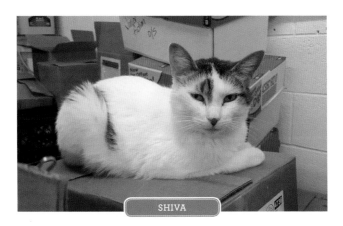

SHIVA

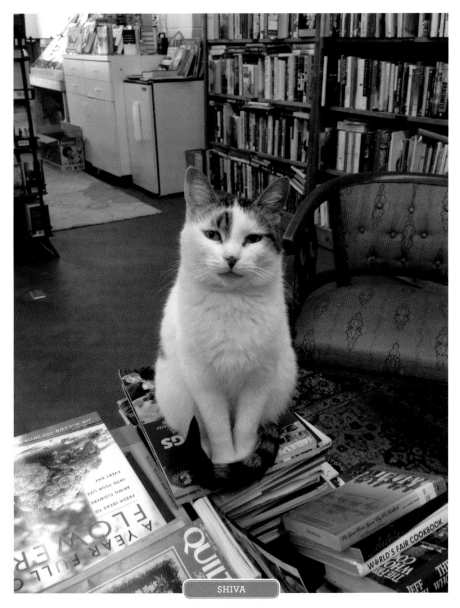

SHIVA

CATS IN CHILDREN'S SERIES

Madame Butterfly

(*Jenny and the Cat Club*
by Esther Averill)

Carbonel

(*Carbonel* by Barbara Sleigh)

Little Bo

(*Little Bo* by Julie Andrews
Edwards)

Tigger

(*Winnie-the-Pooh* by A. A. Milne)

Marco and Polo

(*The Grand Escape*
by Phyllis Reynolds Naylor)

Kitty Cat

(*Kitty Cat, Kitty Cat, Are You
Waking Up?* by Bill Martin Jr.)

Tiny, Moonpie & Andre

(*There Are Cats in This Book*
by Viviane Schwarz)

Earl

(*I Must Have Bobo!*
by Eileen Rosenthal)

Max

(*Max the Brave* by Ed Vere)

Cat

(*Here Comes Santa Cat*
by Deborah Underwood)

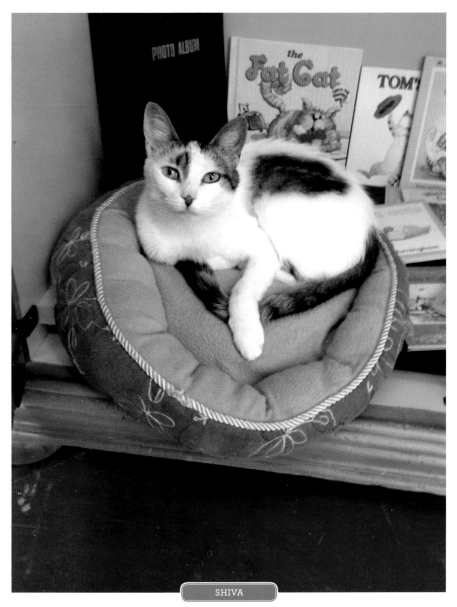

SHIVA

Midwest Pet Refuge story

Midwest Pet Refuge was established in October of 2013 by a group of animal lovers who wanted to help our area's animals. Our focus was on rescue, education, and a spay and neuter program, with the long-term goal of building a new shelter. Our current local shelters are very old and outdated; they're beyond hope of repair.

We started placing pets into foster homes as spaces became available. We successfully adopted out several dogs over the next couple of years, but we had very little luck with cats. From the time we began until the time we opened the store, we only officially adopted out one cat. Cats are simply very difficult to adopt out online, as people want to see them in person before deciding, much more than with dogs. It's even difficult to find foster homes for cats.

In late 2015, we started noticing the cat café trend popping up all over. We wanted to find a location to house our cats, but a shelter is extremely expensive, and we needed to start smaller with something that would help pay the bills as well as house adoptable cats. We began thinking of businesses we could try with a low start-up. We considered a thrift store, but there were already a couple in our area, and food-based businesses were out of the question for obvious reasons! We noticed some charity book sales nearby and knew there were a lot of people who would gladly donate their old

or unwanted books to a good cause, so it finally clicked. I got the idea of a used bookstore/cat adoption center!

With all the sold items coming from donations, all we would need would be a location, bookshelves, and a few other supplies. I was not currently working and had the time to volunteer to run it. I brought the idea up to our rescue's board of directors and, since the start-up costs would be low and it would help adopt out cats, they agreed to go for it!

We started looking at locations immediately, and within a month had found the one. It was low-rent, just big enough for what we needed, right downtown, and it had a recessed doorway and large raised window displays where we could build a cat enclosure to have that "puppy in the window" effect and draw people in. Shortly after we moved in, we built the shelves and started collecting books. We had one generous woman donate two van-fuls, and we still have people coming in weekly with donations.

Cat Tales opened May 5, 2016. From then until December 31, 2016, we were able to adopt out 36 cats, a huge increase over what we'd been able to do before! We were also selling books and making money towards the rent and utilities. Some months we made enough, some not, but we are now able to have fund-raisers at the shop, such as painting parties ("Cats and Canvas"), nail-trim and microchip clinics, and other events to earn the difference. As we continue to grow in popularity with shoppers, adopters, and visitors, we now have people coming in to simply visit the cats on a daily basis.

At the time of this writing, Shiva would like to announce that she has been adopted and has retired from her career as a bookstore cat, but not before training the staff she left behind!

—Tara Drumm, President, Midwest Pet Refuge Manager,
Cat Tales Book Store

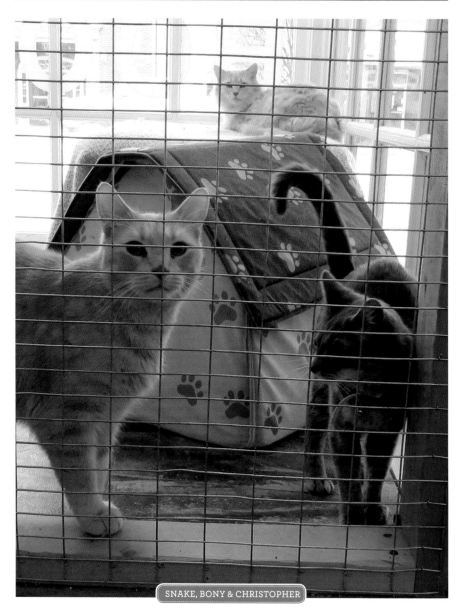

SNAKE, BONY & CHRISTOPHER

Pangur Bán

Pangur Bán and I at work,
Adepts, equals, cat and clerk:
His whole instinct is to hunt,
Mine to free the meaning pent.

More than loud acclaim, I love
Books, silence, thought, my alcove.
Happy for me, Pangur Bán
Child-plays round some mouse's den.

Truth to tell, just being here,
Housed alone, housed together,
Adds up to its own reward:
Concentration, stealthy art.

Next thing an unwary mouse
Bares his flank: Pangur pounces.
Next thing lines that held and held
Meaning back begin to yield.

All the while, his round bright eye
Fixes on the wall, while I
Focus my less piercing gaze
On the challenge of the page.

With his unsheathed, perfect nails
Pangur springs, exults and kills.
When the longed-for, difficult
Answers come, I too exult.

So it goes. To each his own.
No vying. No vexation.
Taking pleasure, taking pains,
Kindred spirits, veterans.

Day and night, soft purr, soft pad,
Pangur Bán has learned his trade.
Day and night, my own hard work
Solves the cruxes, makes a mark.

—Anonymous (translated
by Seamus Heaney)

CATS IN FANTASY NOVELS

Borregad

(*Lyrec* by Gregory Frost)

Fiddle

(*Charmed Life* by Diana Wynne Jones)

Jupiter

(*The Dark Portal* by Robin Jarvis)

Greebo

(*Discworld* by Terry Pratchett)

Austin

(*Summon the Keeper* by Tanya Huff)

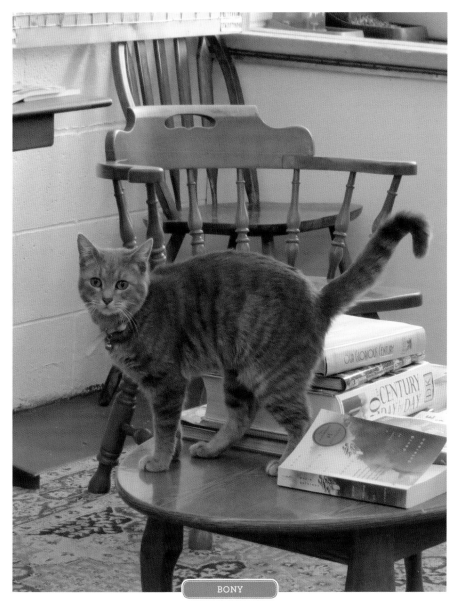

BONY

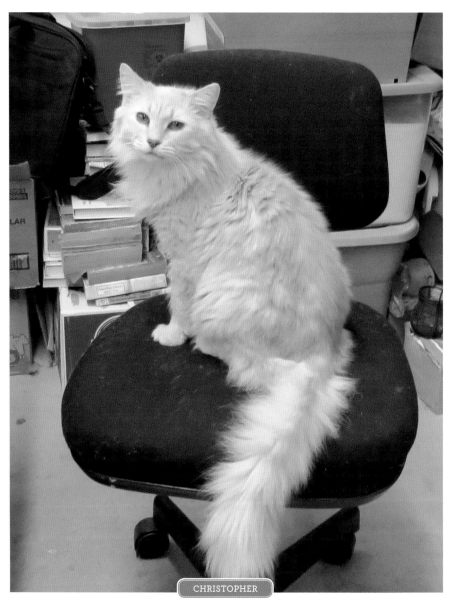

CHRISTOPHER

Hodge the Cat

Burly and big, his books among,
Good Samuel Johnson sat,
With frowning brows and wig askew,
His snuff-strewn waistcoat far from new;
So stern and menacing his air,
That neither Black Sam, nor the maid
To knock or interrupt him dare;
Yet close beside him, unafraid,
Sat Hodge, the cat.

"This participle," the Doctor wrote,
"The modern scholar cavils at,
But,"—even as he penned the word,
A soft, protesting note was heard;
The Doctor fumbled with his pen,
The dawning thought took wings and flew,
The sound repeated, come again,
It was a faint, reminding "Mew!"
From Hodge, the cat...

The Dictionary was laid down,
The Doctor tied his vast cravat,
And down the buzzing street he strode,
Taking an often-trodden road,

And halted at a well-known stall:
"Fishmonger," spoke the Doctor gruff,
"Give me six oysters, that is all;
Hodge knows when he has had enough,
Hodge is my cat."

Then home; puss dined and while in sleep
He chased a visionary rat,
His master sat him down again,
Rewrote his page, renibbed his pen;
Each "i" was dotted, each "t" was crossed,
He labored on for all to read,
Nor deemed that time was waste or lost
Spent in supplying the small need
Of Hodge, the cat.

The dear old Doctor! Fierce of mien,
Untidy, arbitrary, fat,
What gentle thought his name enfold!
So generous of his scanty gold.
So quick to love, so hot to scorn,
Kind to all sufferers under heaven,
A tend'rer despot ne'er was born;
His big heart held a corner, even
For Hodge, the cat.

—Sarah Chauncey Woolsey
(Susan Coolidge)

More Cats in Short Stories

Attab

(*The Philanthropist and the Happy Cat* by Saki)

Cat

(*Cat in the Rain* by Ernest Hemingway)

Tobermory

(*Tobermory* by Saki)

Cat

(*The Cat* by Banjo Paterson)

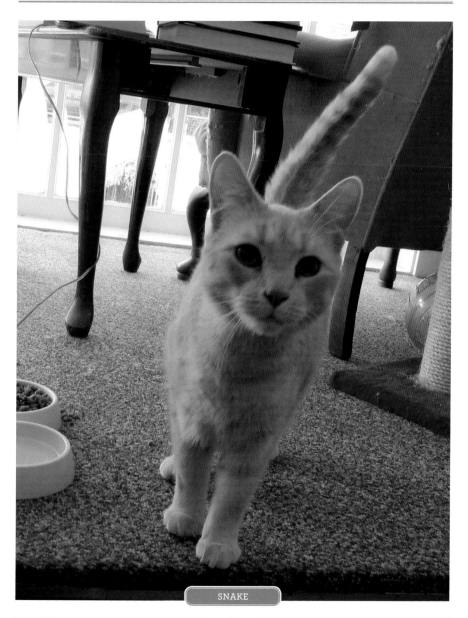

SNAKE

Cats in Picture Books

Thelma, Roger, James & Harriet

(*Catwings* by Ursula K. Le Guin)

Ginger

(*Ginger* by Charlotte Voake)

Kat Kong

(*Kat Kong* by Dav Pilkey)

The Cat

(*Angus and the Cat* by Marjorie Flack)

Sheba

(*April's Kittens* by Clare Turlay Newberry)

Green Eyes

(*Green Eyes* by Abe Birnbaum)

Pete

(*Pete the Cat* by Eric Litwin)

Various Cats

(*Millions of Cats* by Wanda Gag)

Tom Kitten

(*The Tale of Tom Kitten* by Beatrix Potter)

Kitten

(*Kitten's First Full Moon* by Kevin Henkes)

The Cat in the Hat

(*The Cat in the Hat* by Dr. Seuss)

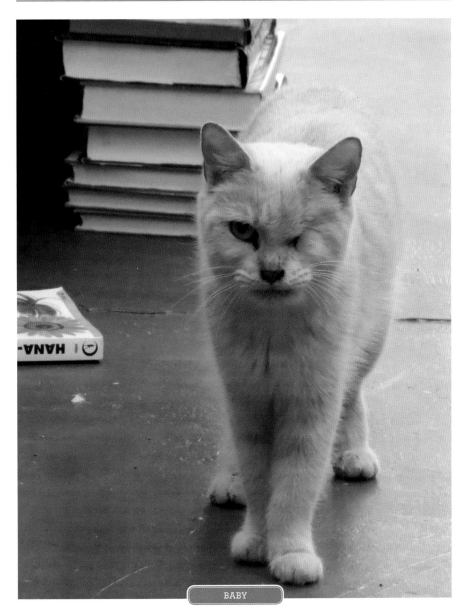

BABY

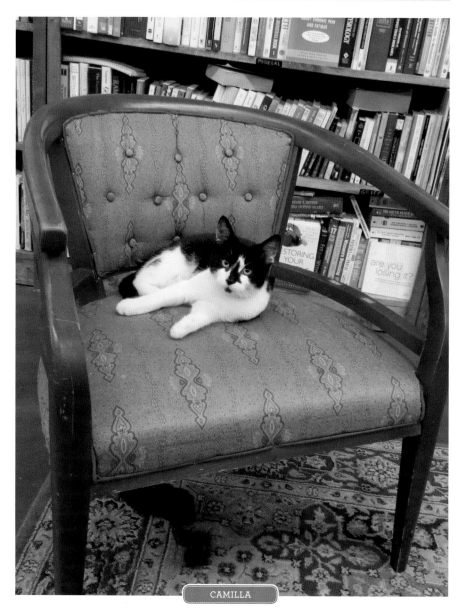

CAMILLA

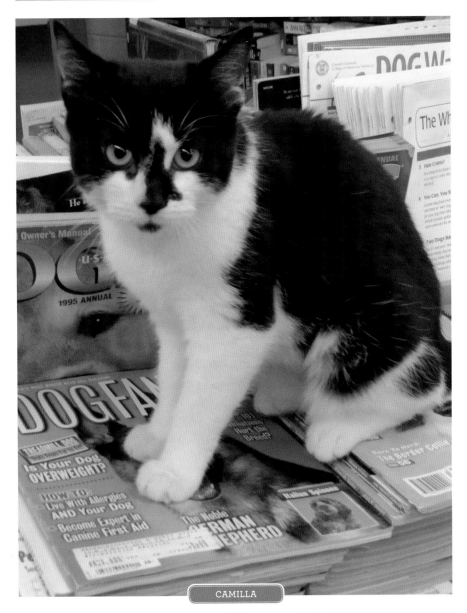

CAMILLA

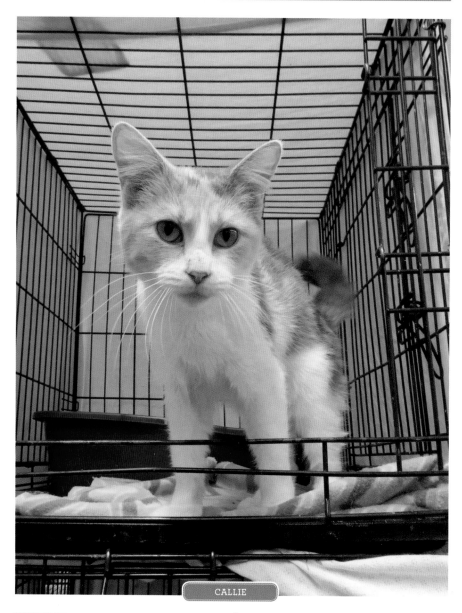

CALLIE

The Kitten and the Falling Leaves

That way look, my infant, lo!
What a pretty baby-show!
See the kitten on the wall,
Sporting with the leaves that fall.
Withered leaves—one—two—and three
From the lofty elder tree.
Though the calm and frosty air,
Of this morning bright and fair.
Eddying round and round they sink,
Softly, slowly; one might think.
From the motions that are made,
Every little leaf conveyed
Sylph or Faery hither tending,
To this lower world descending.
Each invisible and mute,
In his wavering parachute.

But the Kitten, how she starts,
Crouches, stretches, paws, and darts!
First at one, and then its fellow,
Just as light and just as yellow.

There are many now—now one—,
Now they stop and there are none:
What intenseness of desire,
In her upward eye of fire!
With a tiger-leap half-way,
Now she meets the coming prey.
Lets it go as fast, and then;
Has it in her power again.
Now she works with three or four,
Like an Indian conjuror;
Quick as he in feats of art,
Far beyond in joy of heart.
Were her antics played in the eye,
Of a thousand standers-by,
Clapping hands with shout and stare,
What would little Tabby care!
For the plaudits of the crowd?
Over happy to be proud,
Over wealthy in the treasure
Of her own exceeding pleasure!

—William Wordsworth

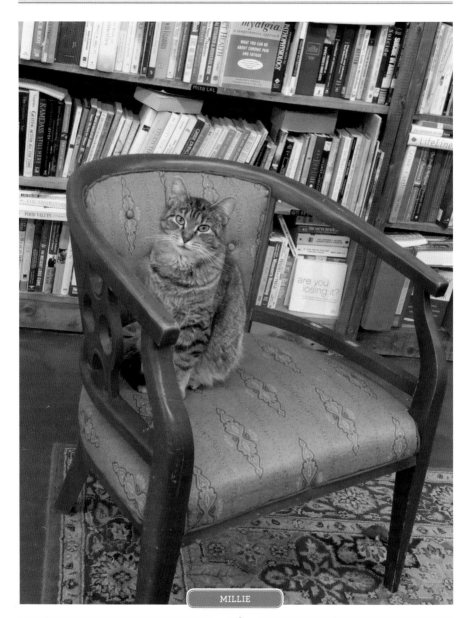

MILLIE

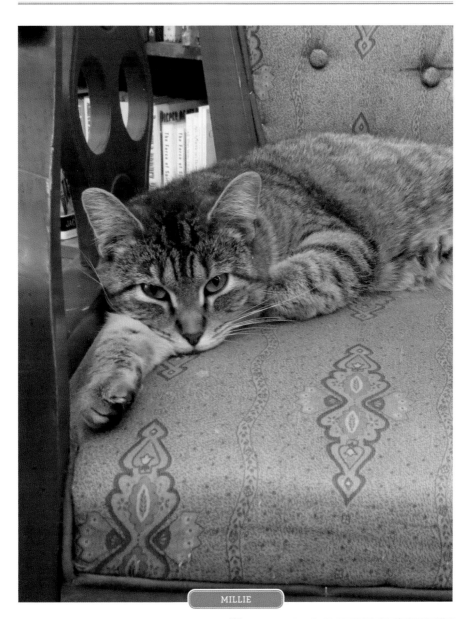

MILLIE

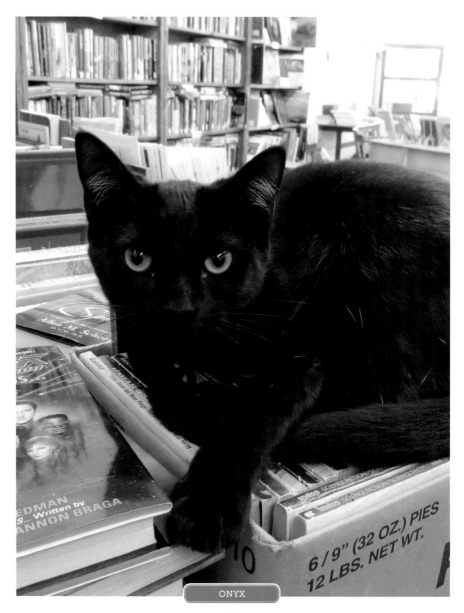

ONYX

More Cats in Poetry

Black Cat

by Rainer Maria Rilke

Poem (As the Cat)

by William Carlos Williams

Lullaby for the Cat

by Elizabeth Bishop

For I Will Consider My Cat Jeoffry

by Christopher Smart

Tame Cat

by Ezra Pound

The Cat and the Moon

by William Butler Yeats

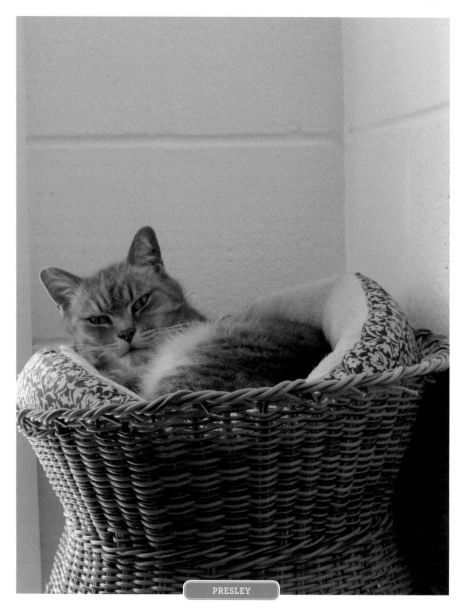

PRESLEY

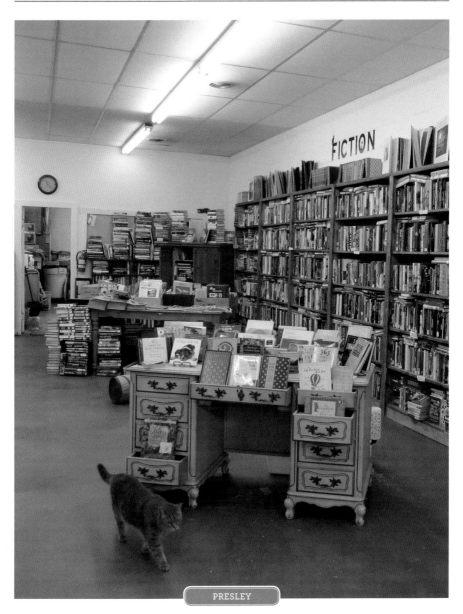

PRESLEY

Cats in Folklore

Yule Cat

(Icelandic)

Wampus Cat

(American)

Kasha

(Japanese)

King of the Cats

(British)

Nekomata

(Chinese)

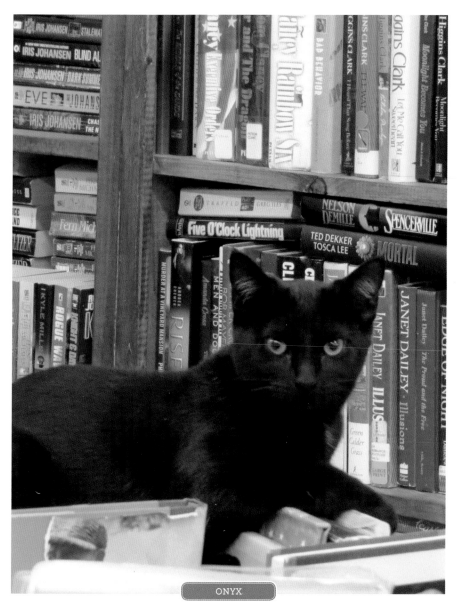

ONYX

Cats Owned by Modern Authors

Solomon

(Lloyd Alexander)

Clovis

(Stephen King)

Mr. Puss

(George Plimpton)

Fletch, Ruski, Spooner & Calico

(William S. Burroughs)

Hermione, Pod, Zoe, Princess & Coconut

(Neil Gaiman)

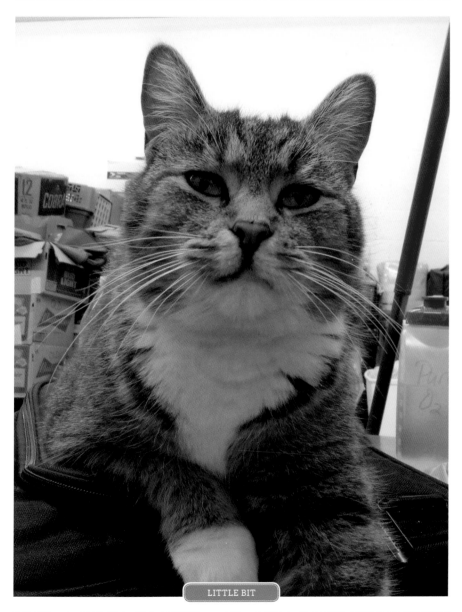

LITTLE BIT

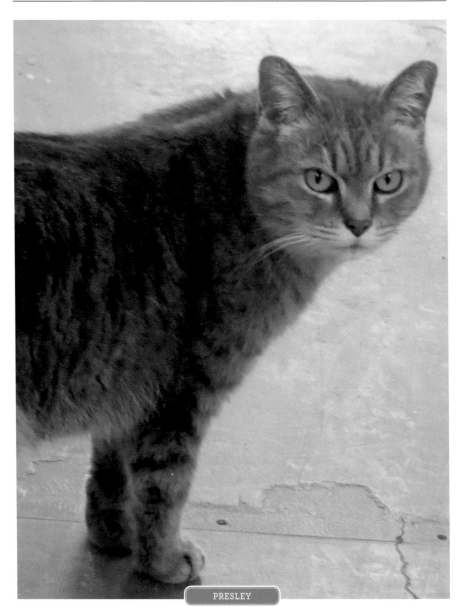

PRESLEY

A Cat

She had a name among the children;
But no one loved though someone owned
Her, locked her out of doors at bedtime
And had her kittens duly drowned.
In Spring, nevertheless, this cat
Ate blackbirds, thrushes, nightingales,
And birds of bright voice and plume and flight,
As well as scraps from neighbours' pails.
I loathed and hated her for this;
One speckle on a thrush's breast
Was worth a million such; and yet
She lived long, till God gave her rest.

—Edward Thomas

Cats in Mythology

Cat Sith

(Celtic)

Barong

(Indonesian)

Chimera

(Greek)

Dola

(Slavic)

Sphinx

(Egyptian)

Sharabha

(Hindu)

Gajasimha

(Southeast Asian)

Lyncus

(Greek)

Lynx

(Germanic)

Merlion

(Singapore)

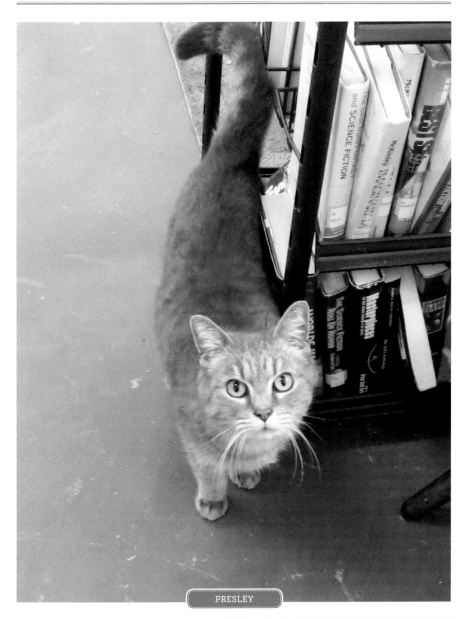

PRESLEY

Cats in Fairy Tales

Puss

(*Puss in Boots*, Italian and French)

Cat

(*The Story of a Cat, a Mouse, a Lizard and an Owl*, Hindu)

Belling

(*Belling the Cat*, Greek)

Cat

(*Why Dog and Cat are Enemies*, Chinese)

Kisa

(*Kisa the Cat*, Icelandic)

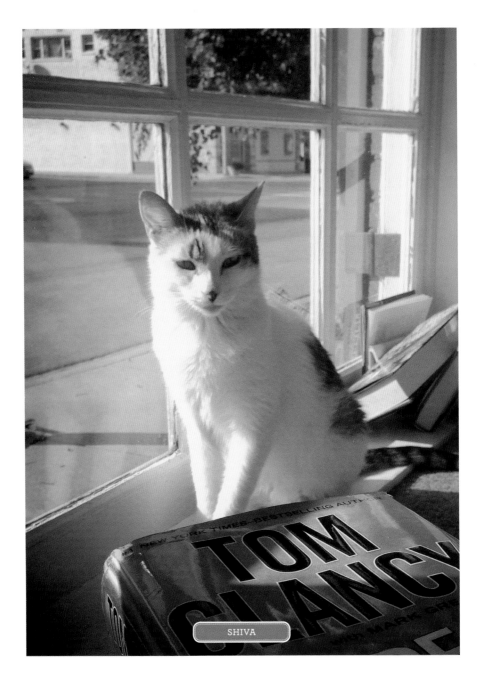

SHIVA

APPENDIX

Abraxas Books
256 S. Beach St.
Daytona Beach, Florida 32114
(386) 307-6478
abraxasbooks.wordpress.com

Books With a Past
2465 Route 97
Glenwood, Maryland 21738
(410) 442-3740
bookswithapast.com

Cat Tales / Midwest Pet Refuge
115 N. Meridian St.
Portland, Indiana 47371
(260) 726-3331
midwestpetrefuge.com

Chop Suey
2913 W. Cary St.
Richmond, Virginia 23221
(804) 422-8066
chopsueybooks.com

Community Bookstore
143 7th Ave.
Brooklyn, New York 11215
(718) 783-3075
communitybookstore.net

Crescent City Books
124 Baronne St.
New Orleans, Louisiana 70112
(504) 524-4997
crescentcitybooks.com

Crooked House Books & Paper
1602 NE 40th Ave.
Portland, Oregon 97232
(503) 249-0344
crookedhousebooks.com

David Mason Books
366 Adelaide St. W.
Toronto, Ontario M5V 1R7, Canada
(416) 598-1015
davidmasonbooks.com

Gallery Bookshop
319 Kasten St.
Mendocino, California 95460
(707) 937-2665
gallerybookshop.com

Hearthfire Books
1254 Bergen Parkway, D118
Evergreen, Colorado 80439
(303) 670-4549
hearthfirebooks.com

Iliad Bookshop
5400 Cahuenga Blvd.
North Hollywood, California 91601
(818) 509-2665
iliadbooks.com

From My Shelf Books & Gifts
7 East Ave.
Wellsboro, Pennsylvania 16901
(570) 724-5793
wellsborobookstore.com

Philadelphia Rare Books &
Manuscripts Company
(215) 744-6734
prbm.com

Postmark Books
449 Main St.
Rosendale, New York 12472
(845) 658-2479
postmarkbooks.net

Recycle Bookstore
1066 The Alameda
San Jose, California 95126
(408) 286-6275
recyclebookstore.com

Rhino Booksellers
4918 Charlotte Ave.
Nashville, Tennessee 37209
(615) 279-0310
rhinobooksnashville.com

Selected Works Used Books
410 S. Michigan Ave., #310
Chicago, Illinois 60605
(312) 447-0068
selworkschicago.com

The Book Barn
41 West Main St.
Niantic, Connecticut 06357
(860) 739-5715
bookbarnniantic.com

The Book Man
45939 Wellington Ave.
Chilliwack, British Columbia V2P 2C6,
Canada
(604) 792-4595
bookman.ca

The Book Man
2630 Bourquin Crescent W.
Abbotsford, British Columbia V2S 5N7,
Canada
(604) 853-7323
bookman.ca

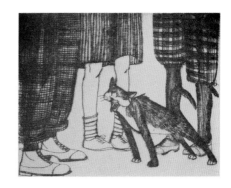

The Kelmscott Bookshop
34 W. 25th St.
Baltimore, Maryland 21218
(410) 235-6810
kelmscottbookshop.com

The Raven Book Store
6 E. 7th St.
Lawrence, Kansas 66044
(785) 749-3300
ravenbookstore.com

The Spiral Bookcase
112 Cotton St.
Philadelphia, Pennsylvania 19127
(215) 482-0704
thespiralbookcase.com

Wild Rumpus
2720 W. 43rd St.
Minneapolis, Minnesota 55410
(612) 920-5005
wildrumpusbooks.com

Lebens-Ansichten des

Kater Murr.

von
E. T. A. Hoffmann.

Zweiter Band.

Berlin,
Ferd. Dümmler's Verlagsbuchhandlung.
1855.

Acknowledgments

True thanks to each of the following, who inspired and assisted in these and other ways:

For discovering the joy of bookstore cats and noting the book potential therein, and for choosing me to curate this collection for her, Marta Hallett.

For taking my collection and creating something so charming with it, Liz Trovato.

For stalking so many store owners and cheerfully gathering data in my most desperate days of outreach, Emily Hilton.

For making my life easier and sillier every day, Coco Romack, with a hat-tip to Piet.

For constant encouragement and unconditional support in all of my crazy endeavors, and for sitting at Barnes & Noble café tables for countless hours while I wrote this book, Jeff Panko.

And for adopting and employing the cats who have found better lives within bookstores, the owners and staff of the wonderful stores featured here.

And to the many, many other bookstore cat owners who also help to make the world more welcoming by supporting books, cats, and community.

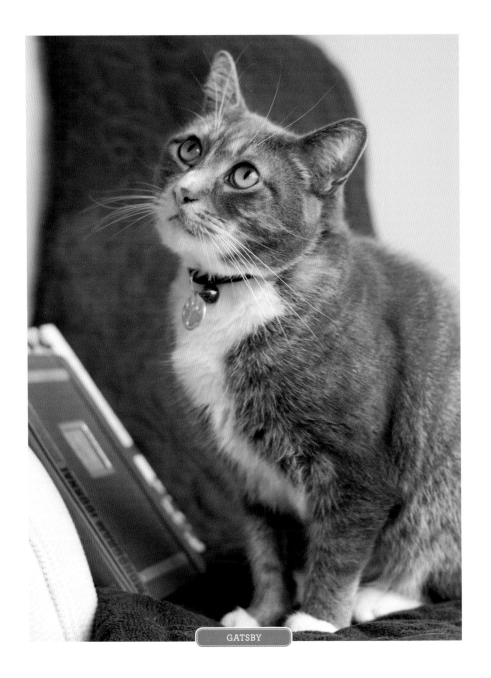
GATSBY